IMAGES
of America

ALONG THE
CHICAGO SOUTH SHORE
& SOUTH BEND RAIL LINE

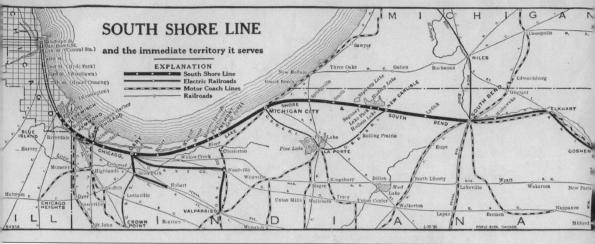

This map of the Chicago South Shore and South Bend Railroad's (CSS&SB) route was originally published in "First and Fastest," a brochure issued by the railroad in 1929 to celebrate its successes under the aegis of Samuel Insull Sr., the renowned utilities magnate of the era. (Courtesy of Calumet Regional Archives.)

ON THE COVER: The parlor car was part of the luxury service offered by the CSS&SB after Sam Insull Sr. took over the line in 1925. For a small supplement, a traveler could sit in near-private comfort, ride in the observation section, or purchase refreshments en route. Many passengers paid the extra money at least once just so they could say they had experienced first-class train service. (Courtesy of Calumet Regional Archives.)

IMAGES
of America

ALONG THE
CHICAGO SOUTH SHORE
& SOUTH BEND RAIL LINE

Cynthia L. Ogorek

ARCADIA
PUBLISHING

Copyright © 2012 by Cynthia L. Ogorek
ISBN 978-0-7385-9419-4

Published by Arcadia Publishing
Charleston, South Carolina

Printed in the United States of America

Library of Congress Control Number: 2012941377

For all general information, please contact Arcadia Publishing:
Telephone 843-853-2070
Fax 843-853-0044
E-mail sales@arcadiapublishing.com
For customer service and orders:
Toll-Free 1-888-313-2665

Visit us on the Internet at www.arcadiapublishing.com

CONTENTS

ACKNOWLEDGMENTS

As they say, "It takes a village." The following people have made this book possible with their individual specialties.

Bill Molony, president of the Blackhawk Chapter of the National Railway Historical Society, stepped up enthusiastically with encouragement and suggestions as always, as did Mike Wagenbach of the Pullman State Historic Site and Mark Bouman of the Calumet Heritage Partnership.

I thank Paul Pobereyko for introducing me to the Northern Indiana Commuter Transportation District (NICTD), and I thank the NICTD staff for providing research material.

Thank you, Peter Youngman, for once again delving into your wealth of railroad information and photographs.

I thank these people for their gracious hospitality and willingness to probe the archives just one more time: Dana Groves, the executive director of Historic New Carlisle, Inc., who went out of her way to help, as did Steve McShane of Calumet Regional Archives; Rod Sellers of Southeast Chicago Historical Society; Richard Lytle of the Suzanne G. Long Local History Room at the Hammond Public Library; Tricia Hodges and Judith Collins of the Indiana Dunes National Lakeshore; Frank Hurdis and Paul Diebold of the Indiana Department of Natural Resources, Division of Historic Preservation and Archaeology; and Charles Werner of the Illinois Central Railroad Historical Society in Paxton, Illinois. My appreciation is also extended to Kristen Madden at the Northern Indiana Center for History archives; David Hess and staff of the Gary Public Library; Susie Richter, curator of the LaPorte County Historical Society Museum; and all the research librarians at the East Chicago, Michigan City, and St. Joseph County Libraries.

And thank you Robert Pence for coming through at the last minute and in a hurry.

Unless otherwise stated, the images in this volume appear courtesy of the LaPorte County Historical Society (LCHS), the Illinois Central Railroad Historical Society (ICRRHS), the Calumet Regional Archives (CRA), the Indiana Dunes National Lakeshore (IDNL), and the Southeast Chicago Historical Society (SCHS).

Please note that in the text the Chicago Lake Shore and South Bend Railroad is referred to as the LS, the Lake Shore, and the CLS&SB. The Chicago South Shore and South Bend Railroad is referred to as the SS, the South Shore, and the CSS&SB.

INTRODUCTION

On quiet nights, I can hear the horn of the South Shore train as it glides between Hegewisch and Hammond, reminding me of all the times I have ridden it from Hegewisch to Chicago. I will never forget how crowded and overheated the little Hegewisch Station could get at Christmas time when my mom took my brother and me downtown to see Santa Claus. Sometimes it was just as bad in the summer when we left from that station to go into Chicago to see ballgames and museums. As a grown-up, I sat on the hard, wooden, pew-like bench waiting for the train, amused by the clientele that sat at the lunch counter on the other side of the room and fascinated by the "Hav-a-Hank" handkerchief display hanging on the wall over the hot-chocolate machine.

I never rode to South Bend until my mother suggested the trip in the early 2000s after telling me that she and her mother had made the trip once, just for fun.

The idea for writing this book came out of my experiences as a tour guide on the South Shore, where I found that people were intrigued just as much by what they saw out the windows as by the experience of riding the last electric interurban in the country.

The South Shore railroad (CSS&SB), which began its life in 1908, was the successor to the Chicago Lake Shore and South Bend Railway (CLS&SB or LS) and the even earlier Chicago and Indiana Air Line. The latter was a 3.4-mile trolley line incorporated in 1901 to run between East Chicago and Indiana Harbor. The year 1908 has become the official founding date of the CSS&SB because that was when, as the Chicago Lake Shore and South Bend (reincorporated and renamed in 1904), it began operating between South Bend and Michigan City, thus becoming a true interurban.

With the new name came a new owner, who built the line according to steam railroad standards, with heavier rails and no sharp curves. By September of 1908, ten trains per day were rolling from South Bend into Hammond; however, the railroad needed to make a direct connection with downtown Chicago in order to be profitable. This was accomplished in 1908 by leasing the Kensington & Eastern Railroad built by the Illinois Central between 115th Street in Chicago and the Indiana border.

As the economic strength of the Calumet region grew, the Lake Shore looked for more ways to increase its bottom line. Freight was the solution, and those flat curves paid off, allowing a heavier locomotive to move the first boxcar from Cummings Siding in South Bend to Chicago on August 1, 1916.

Tonnage and income steadily rose after World War I. Yet, unrelenting competition within the transportation industry from steam railroads, trucks, and the private automobile caused the LS to go bankrupt. In 1925, it was purchased for its scrap value by Midland Utilities, the so-called "Insull Empire."

Electric utilities magnate Sam Insull Sr. had taken control of the Chicago Elevated Railways in 1911. This led to his acquisition of the three big electric interurbans serving Chicago: the Chicago North Shore & Milwaukee (CNS&M) in 1916 and the Chicago Aurora & Elgin

(CA&E) in 1925, followed by the CLS&SB, which he renamed the Chicago South Shore and South Bend.

Hitting the ground running, Insull's team made track usage agreements with the Northern Indiana Railway and the Southern Michigan Railway electric interurbans. South Shore freight stations and passenger platforms were enlarged and painted mahogany and orange, the railroad's new colors. A new passenger station appeared on the corner of LaSalle and Michigan Streets in South Bend. The Gary and Tremont stations were rebuilt, and Michigan City's Eleventh Street Station was remodeled. A standard design for shelters was implemented at all flag stops, and 25 new steel passenger coaches, two dining cars, and two parlor-observation cars were ordered from the Pullman Car & Manufacturing Corporation in Chicago. Four 80-ton Baldwin-Westinghouse steeple locomotives were purchased for the freight division. Old coaches were cleaned up and repainted in orange and mahogany as well. Schedules were expanded to add 28 daily trips.

Rehabilitation of the line's infrastructure included new creosoted track ties, heavier angle bars, regrading, re-ballasting, and heavier rails. Sidings were lengthened and changed to "double-enders" equipped with high-speed turnouts. The roadbed was widened, drainage improved, and trees, brush, and weeds were cleared off the entire right-of-way. New bridges were constructed, while serviceable old ones were cleaned and painted. The entire signal system was replaced along with upgrades to telephone lines.

Meanwhile, the IC suburban line had fulfilled its obligation to the City of Chicago by changing from steam to electric power in the summer of 1926. Now, all the South Shore had to do was change to 1500-volt DC service and it could make the trip all the way to Randolph Street under its own power.

Originally, the South Shore had used 6600 volt AC, or "alternating current," to run its cars. This single-phase system eliminated the drop in electrical voltage over a given distance and allowed the railroad to use fewer substations than a DC, or "direct current," system needed. Substations housed the equipment, which either stepped up or stepped down electricity coming from the larger generating plant before it was directed to the terminal, in this case, the catenary wires that served the electric trains. In order to comply with the IC's system, the South Shore changed to direct current. At distances of 6 to 10 miles, the Midland-owned Northern Indiana Power Service Company, which provided the South Shore's electric power, installed eight new substations and accompanying feeders. In these two-story brick substations, the AC current was stepped down and converted to DC by motor-generator units.

The Illinois Central's relationship with the South Shore was traditionally cordial. After the buyout by Midland, it was also economically and financially beneficial to both sides. Midland's Commonwealth Edison, an Illinois electric utility, was the IC's largest coal-shipping customer, and at that point the IC was also one of Com Ed's largest electric-power customers.

The "convenience of the patron" was stressed during the Insull years, both for passengers and freight customers. Employees were continually reminded that they were in the service of the public and that Midland Utilities was the best public-service organization in the world. Employees were showered with fringe benefits and were also required to do community volunteer work.

This, however, did not impinge on Midland's profitability. Insull, a master of "cross selling," understood the value of good transportation service to real estate development—both residential and industrial—which would, in turn, expand the market for his utility companies.

From the Midland offices in the Peoples Gas Building and three information bureaus located at 72 West Adams Street in Chicago, publicity flowed to the public about where to go in northwest Indiana, what to see there, and how to get there via the South Shore. The Own Your Own Home Bureau provided information about building a house in northwest Indiana. The Outing and Recreation Bureau publicized outdoor and resort activities. The Public Speaking Bureau sent lecturers out to interested groups with movies and slide shows. The company even built a scale model of its freight and passenger service to explain the catenary system to the public.

To further increase the reach of the South Shore, the "Golden Arrow" motor coach route between Chicago and Detroit was established in 1927 with once-daily eastbound and westbound

"limited" trains offering white tablecloth meal service and a smooth transfer to and from the buses at South Bend.

By the late 1920s, the South Shore had connections with all the important transcontinental railroads and all the new factories that had appeared along its corridor. By 1928, freight revenue had reached nearly $1.25 million per year.

Unfortunately, hard times were around the corner. After the stock-market crash in 1929, the Depression took its toll through 1930, and then Insull's "empire" was dismembered. Revenue dropped in 1931, and Midland collapsed in 1932. Dining and parlor-car service were ended. The South Shore declared bankruptcy in 1933 and again in 1938. To bolster the bottom line, management made the most of its biggest assets, which were its steam line interchanges and through rates. It also established a nationwide freight sales force and diversified its cargoes. Revenues slowly picked up through the rest of the decade.

During the World War II years, the South Shore carried more passengers than it ever had before—over six million in the years 1945 and 1946. After the war, its freight division benefited from the postwar economic boom. On the downside, however, passenger revenues began to decline.

Competition from over-the-road trucking and private automobiles became worse due to the Interstate Highway System. For instance, the Indiana Toll Road, which opened in 1956, paralleled the entire length of the SS from South Bend to Hammond; however, because of its connections with some 14 trunk rail lines, the South Shore freight division was a recognized player in the Calumet-South Bend region. It did a great business hauling coal to local generating plants and hauling commodities that originated on other lines.

Since the Depression, with the exception of the World War II era, passenger service had been problematic. In 1967, the Chesapeake & Ohio System, one of the first railroads to scale back passenger service in the 1950s, took control of the South Shore. While the SS retained its separate identity and its own officers, the C&O sought its profits from the freight division and was very reluctant to put money into the passenger side. Station restaurants, motor-coach service, and the number of trains per day were cut or reduced. The situation became known as "the passenger problem."

By the 1970s, while the C&O understood that passenger service was a public convenience and a necessity, it refused to continue the service at its current level without government subsidies. But Indiana's local and state governments had no desire, much less a plan, to help. C&O kept pointing out that there were federal funds available and that all the state had to do was authorize a regional transportation body. Legislators could not, however, understand why a company making a profit needed government subsidies.

While the Illinois Central benefited from government funding, the C&O just kept cutting service while providing only essential maintenance on the passenger equipment. In 1972, the Interstate Commerce Commission (ICC) allowed service cuts that eliminated non-rush hour trains, while the Illinois Regional Transportation Authority contributed funds to support service in Hegewisch. In 1975 and again in 1976, the State of Indiana attempted to organize a regional transit authority. When those tries failed, the C&O once again petitioned to abandon passenger service.

That year, passengers began to rally and organized the Save our South Shore (SOSS) committee in Michigan City. It published a brochure describing the Indiana government's shortcomings, the potential economic and environmental results if service were terminated, and the business nature of any passenger rail service that must make a large investment in cars that sit idle most of the time. The committee concluded that, overall, "the efficiency of rail passenger service is many, many times that of private automobiles." Contemporaneously with SOSS, South Shore Recreation in Chicago began to promote the use of the train for recreational purposes both eastbound and westbound. It also exhorted readers to be in touch with local politicians to encourage the support of the railroad.

Meanwhile, the ICC, despite the calamity that abandonment would bring, told all parties that they had until February 1977 to hold hearings, proceed with any necessary studies, analyze the findings, and make a decision; otherwise, the commuter line would be terminated.

In April 1977, the Northern Indiana Commuter Transit District (NICTD) was authorized to use federal, state, and local funds to support the South Shore Line passenger service, while the "South Shore" operated the freight division. Officials of St. Joseph, Lake, Porter, and LaPorte Counties would oversee the use of funds.

NICTD shortly thereafter purchased 44 cars at $1.25 million each. In January 1981, the first new cars arrived for testing. Two years later, 44 stainless-steel, electric, multiple-unit cars—all 85 feet long—were delivered. To accommodate them, maintenance facilities and substations at Michigan City were improved. The new cars went into service in 1982, and as they came on line, the Insull cars were sold or given away to various organizations, individuals, and railroad historical societies.

In 1983, NICTD offered to buy the South Shore from the C&O, but the Venango River Corporation (VTC) got there first. Its purchase was completed in September 1984.

At that point, federal subsidies to the passenger service began to decline. In 1985, NICTD appealed to the Indiana General Assembly for local taxing authority, citing that it was the only public-transit body in the state that did not have such ability. Instead, the state gave NICTD a loan of $2.6 million, which, in part, was to be used to pay for an investigation into the need for rail commuter service in northwest Indiana and an audit of the VRC/NICTD books. The results of the study showed that commuter service was indeed necessary to the region and that NICTD was a competent manager. The study also suggested that revenues might be increased if more were done to increase non–rush hour ridership. In 1987, the Indiana General Assembly successfully introduced legislation to provide local tax support.

Meanwhile, VRC, with its capitalization based on debt, had overreached its financial abilities and declared bankruptcy in April 1989. Toward the end of the year, NICTD negotiated a deal with Anacostia & Pacific, the would-be new owner. The deal closed on December 31, 1990, with the result that A&P brought the South Shore Line assets out of bankruptcy and then sold the passenger assets to NICTD. A&P also provided an option for NICTD to buy the main-line trackage in Indiana within three years.

A&P retained ownership of freight trackage and other freight assets, including the Michigan City shops and office building and the Burnham and Lincoln freight yards. It also changed the name of the railroad to Chicago SouthShore & South Bend and referred to itself as SouthShore Freight. With the passenger and freight operations legally separated, NICTD and SouthShore Freight were able to concentrate on their respective strengths.

In its run from downtown Chicago to the outskirts of South Bend, the South Shore has traditionally been one strand in a regional transportation braid that parallels, intersects, or crosses the Illinois Central Railroad, the Calumet River system, the Cal-Sag Channel, the Indiana Harbor Ship Canal, the Indiana Toll Road, Interstate 65, US Routes 12 and 20, the remains of more than a dozen earlier steam lines now called Amtrak and CSX, and the Michiana Regional Airport.

Travelers boarding at Randolph Street in downtown Chicago ride through the urbanized residential areas of the South Loop and Hyde Park Township with glimpses of Lake Michigan between the high-rises. As the train makes the turn eastward at 115th Street, it enters the flat, swampy Lake Plain along the Lake Michigan shore and the Calumet River Valley, where the industrialized Calumet region begins. East of Gary and the mills of US Steel, the scenery changes to the Indiana dunes country of Porter County, followed by farms and a lake district in LaPorte County and forests in St. Joseph County before it pulls into the gleaming pocket track at its station in the Michiana Regional Airport on the west side of South Bend.

In 2008, when the South Shore celebrated its 100th anniversary, it was on solid footing. The freight business was booming, and the passenger service revenues were split about halfway between fares and government subsidies. The line was also more than halfway through a $124 million upgrade of the system—the largest infusion of capital since the Insull days.

In many ways, and despite some dramatic intervening situations, the development of a railroad and a region that Sam Insull envisioned has been realized.

One
AIRLINE TO INTERURBAN

In 21 years, the South Shore expanded from a 3.4-mile trolley run in East Chicago, Indiana, to a 90-mile interurban passenger and freight route between downtown South Bend, Indiana, and the heart of the "Loop" in Chicago. It successfully negotiated with the Illinois Central Railroad (IC) to use its trackage in the city of Chicago and to lease from it a short line, the Kensington & Eastern, which the IC built specifically to connect its line in Chicago with the South Shore in Indiana. It changed owners four times, began offering excursion trips, opened a freight division, and upgraded from streetcars to the heavier interurban electric cars. Yet, insurmountable difficulties brought it to bankruptcy and near failure.

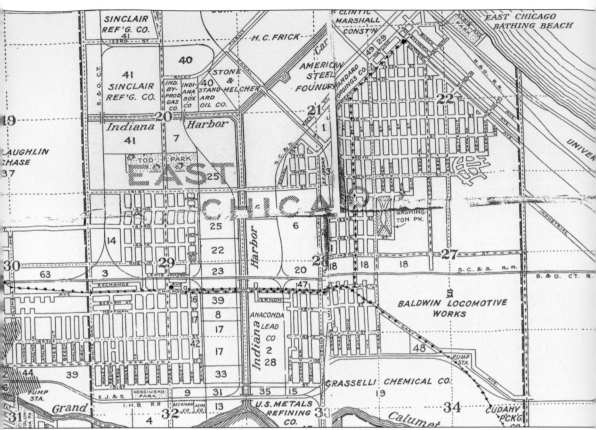

Incorporated in 1901, the Chicago & Indiana Air Line Railway, a 3.4-mile trolley line (see the crosses here), ran two 44-seat cars built by J.G. Brill of Philadelphia between the corner of Guthrie Street and Michigan Avenue in Indiana Harbor (the dot in upper-right area) to a terminal in East Chicago at the corner of Forsyth Street (later Indianapolis Boulevard) and Chicago Avenue. In 1904, the name of the company was changed to the Chicago, Lake Shore & South Bend Railway (LS), promoting the firm's intention of operating an interurban between South Bend and Chicago. The LS had a storefront station on Chicago Avenue in downtown East Chicago (the dot in lower-left area), and the route (follow the smaller dots) went west (left) on Chicago Avenue into Hammond and east on Chicago Avenue, curving to the southeast on its way over the Grand Calumet River into Gary. The original route became the Green Line trolley. (Author's collection.)

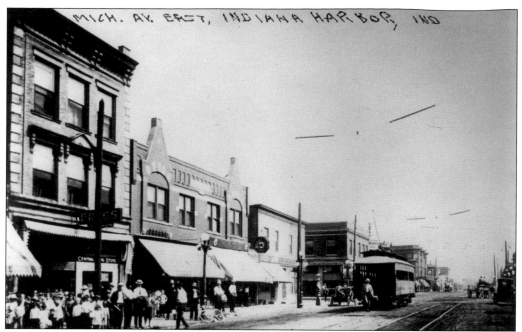

The C&I Airline, or Green Line trolley, is seen here on Michigan Avenue in Indiana Harbor. The trolley lines were important for bringing shoppers to the business district and transporting workers from home to Inland Steel, Standard Oil, and other industrial firms along the Indiana Harbor Ship Canal. But it was impossible to make a profit with such a short route. (Courtesy of CRA.)

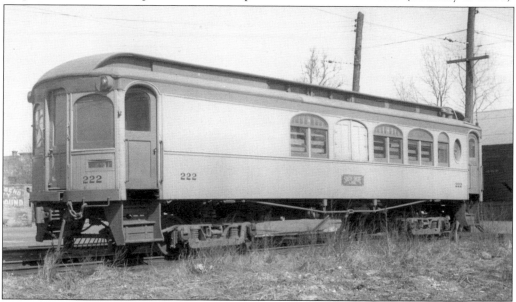

The Niles Car and Manufacturing Company of Niles, Ohio, built 24 interurban passenger cars of wood and steel for the CLS&SB in 1908. With a length of 57 feet, two inches and a width of 10 feet, they weighed more than 55 tons each and were built to steam railroad standards. Nine of these cars were combination passenger-baggage cars (like car 222 seen here) and were called combines. The exteriors were painted in three shades of maroon with silver lettering. (Courtesy of CRA.)

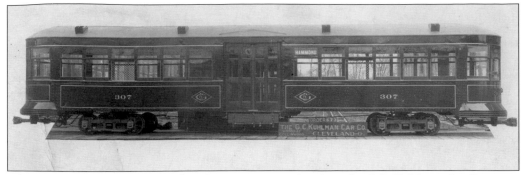

Also, in 1908, the CLS&SB purchased 10 passenger trailers from the G.C. Kuhlman Car Company of Cleveland similar to the one seen here. Trailer cars had no motors and could not operate on their own. (Courtesy of CRA.)

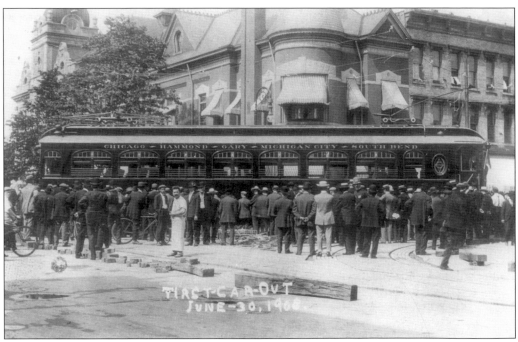

The LS's inaugural run took place on June 30, 1908, when it left Michigan City on a 32-mile run to South Bend. Due to mechanical difficulties, the trip took over three hours, but the return took only 1 hour and 15 minutes. Car 1 is shown here backing in and out of the wye on Colfax Avenue and Main Street in downtown South Bend prior to the return trip. (Courtesy of CRA.)

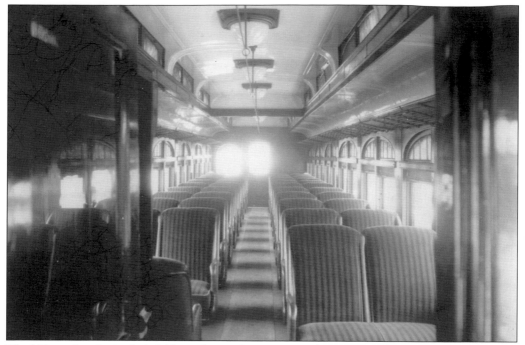

The Niles order also included 15 coaches with separate smoking areas. The interiors of the 62-seat coaches were decorated in buff and light green with dark mahogany woodwork and black leather upholstery. Ceilings were in the Empire style, featuring opalescent dome lights with individual lamps over each seat mounted on bronze brackets. The interior of this car is seen here after its refurbishment in 1927. (Courtesy of Northern Indiana Center for History.)

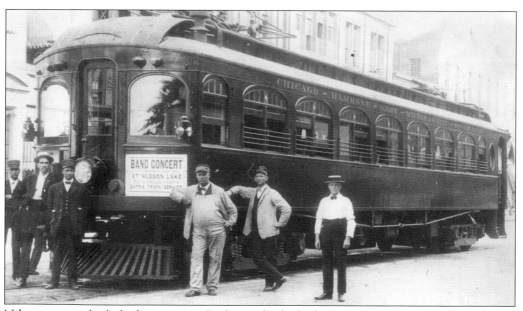

Niles cars were built for longer trips. Each car also had a lavatory equipped with a Peter Smith hot-water heating system. In order to boost interest in the railroad, the LS began offering excursion rates and ideas for group outings by train. (Courtesy of CRA.)

With regular service from South Bend to Michigan City now established, Lake Shore passengers wishing to continue to Chicago could transfer to a steamship at Michigan City. It was a nice summer excursion for those who had the time, taking about three hours. Westbound travelers might also have considered it an exotic change of pace from train travel. (Courtesy of LCHS.)

A few months later, the line was open as far west as Hammond. At the Calumet stop, east of East Chicago, passengers could transfer to the passenger service of the Lake Shore and Michigan Southern (LS&MS) steam line (seen here), which later became part of the New York Central system. This train terminated at the LaSalle Street Station in downtown Chicago. (Courtesy of LCHS.)

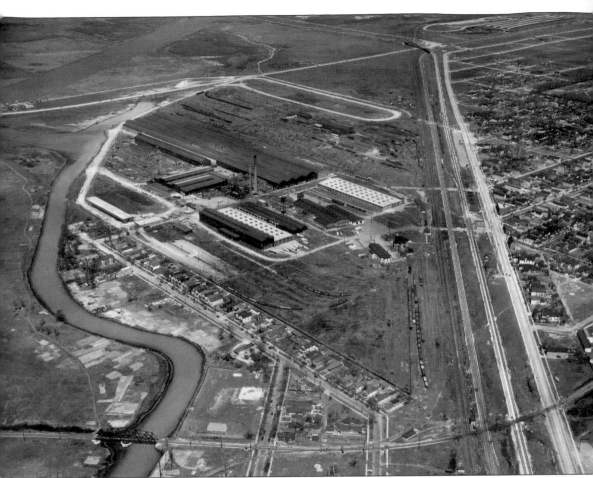

The plans of the CLS&SB were completed when the Kensington & Eastern line opened in April 1909. This short line was built by the Illinois Central Railroad and leased to the CLS&SB as a means of connecting the IC right-of-way at Pullman/111th Street Station through Hegewisch to the CLS&SB at the Indiana border. Shown here is the portion of the K&E through Hegewisch during World War II. The rail line at the bottom is the old South Chicago & Southern, which became part of the Penn system. The bridge on the left crosses the Grand Calumet River in Burnham. The three vertical parallel lines are, from left to right, the Monon and C&WI Railroads, the South Shore, and Brainard Avenue. The factory with the two white roofs is Pressed Steel. Above Pressed Steel are the buildings of the Aero Coach Company. At the very top of the photograph, the South Shore crosses Torrence Avenue. The South Shore passenger station is shown on Brainard Avenue at the lower crossing to Pressed Steel. (Courtesy of SCHS.)

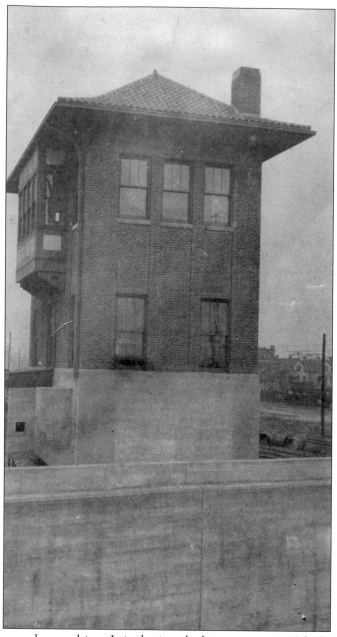

This building changed everything. It is the interlocking tower at 115th Street in Chicago's Kensington neighborhood. With it, non-transfer through service for the CLS&SB was initiated in 1912. The operator on duty in the tower was able to switch tracks to allow the South Shore to pull up to the IC platform, where the train was coupled to an IC steam locomotive. Although this took time, it was much more convenient to passengers than disembarking and crossing over to an IC train. After that, seven LS trains a day in each direction pulled into Kensington, changed from steam to electric or from electric to steam power, and went on their way into Chicago or Indiana, respectively. Passengers no longer had to disembark to transfer, and ridership numbers soon increased to reflect this convenience. The switching service was an improvement for the Michigan Central Railroad, which also used the IC right-of-way. (Courtesy of ICRRHS.)

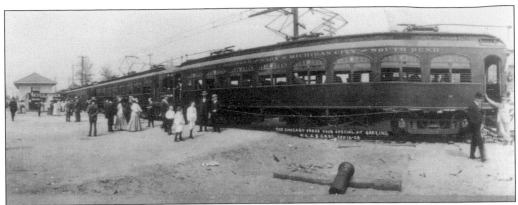

The CLS&SB was having financial difficulties when the Warren Bicknell Company of Cleveland took over in October 1909. The new management made every effort to capitalize on employee or social group outings to places like Michigan City, the dunes, and Hudson Lake in Indiana. Here is an excursion group from the Chicago Press Club in 1908 taking a break at the Gary station. (Courtesy of CRA.)

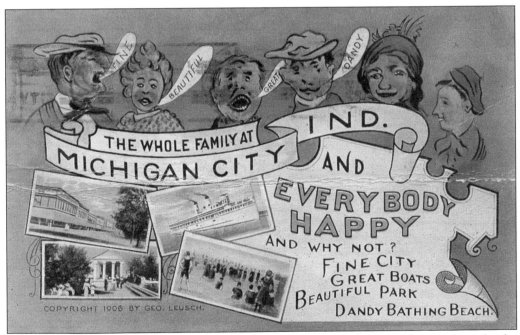

Michigan City actively promoted its beaches and Washington Park as suitable attractions for the whole family, whether they arrived by boat or train. Postcards like this one and a raft of others assisted the CLS&SB in bringing more and more people out to the shores of Lake Michigan. Washington Park was a big draw for day-trippers. Vacationers could rent cottages on the beach east of town. (Courtesy of LCHS.)

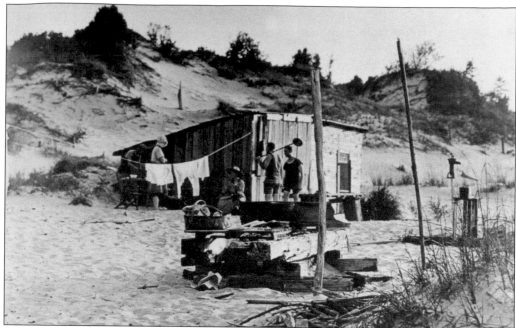

One of the most famous groups to ride the train was the Prairie Club, which originated in the Chicago area. Members started with afternoon hikes through the dunes in Porter County before establishing a camp so that they could spend several days enjoying the flora, fauna, beach, and like-minded campers. It was through trips like these that the idea for the Sand Dunes National Park took shape. (Courtesy of IDNL.)

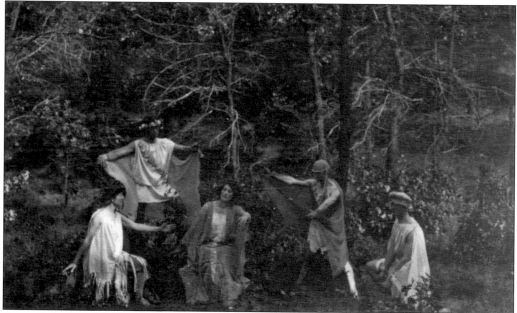

As more people gained access to the dunes via the LS, they began to understand its natural importance and tried to have it made into a national park. To promote the beauty of a wilderness so close to a big city, pageants featuring nymphs and other woodland creatures were staged in order to attract yet more people. (Courtesy of IDNL.)

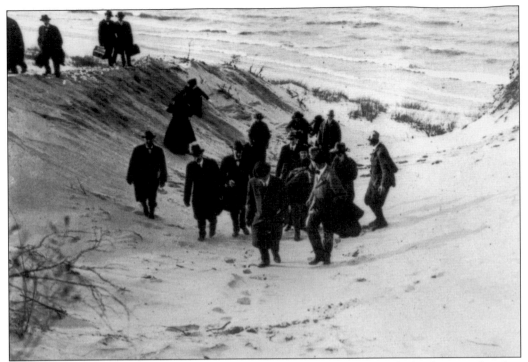

Stephen T. Mather and Horace Albright lead this group on a trek through the dunes in October 1916. Mrs. Albright is second from the right in the photograph below. Horace was the first National Park superintendent of Yellowstone Park and the second director of the National Park Service (NPS). Mather became the first director of the NPS and formally recommended the dunes to be a national park in 1916. This outing was part of the hearing held in Chicago for this purpose. Sadly, even with all the promotion, the dunes did not become part of the NPS (as the Indiana Dunes National Lakeshore) until 1966 after much of it had been taken for steel mills and a port. The best Indiana could do in 1925 was to designate three and a half square miles in the vicinity of Waverly Beach as the Indiana Dunes State Park. (Courtesy of IDNL.)

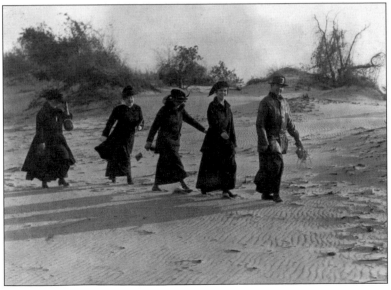

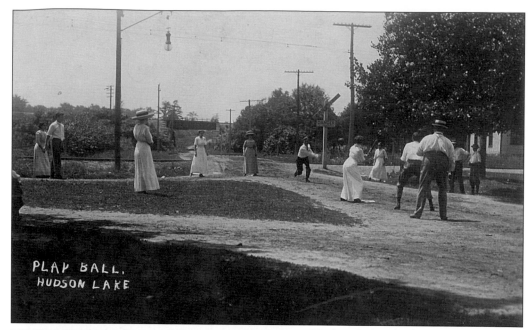

PLAY BALL,
HUDSON LAKE

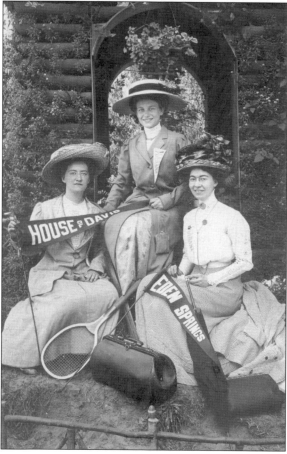

Hudson Lake, the last stop in LaPorte County, might have been the Chicago Press Club's destination. Many companies ran "picnic specials" there during the summer. Vacationers could come out to play baseball, go boating or fishing, or take walks around the lake. One year, the Pullman Company chartered an 11-car train to take some 900 employees for the day at Hudson Lake. (Courtesy Historic New Carlisle.)

Longer trips could be made by taking the LS to South Bend. There, travelers like these Chicago girls would transfer to the Southern Michigan Railway, which took them to St. Joseph, Michigan. Eden Springs was a Jewish resort in Benton Harbor, across the river from St. Joe. During their vacation, these ladies probably enjoyed an afternoon at a ball game played by the House of David team. (Author's collection.)

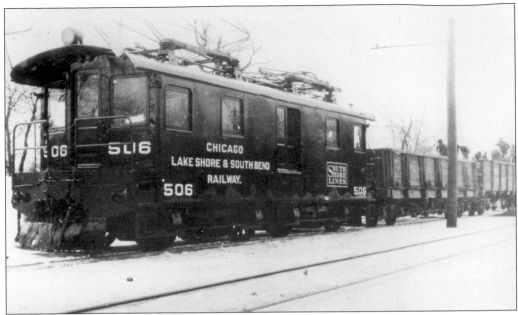

Tourist business and combine-car freight were not enough to keep the LS profitable. In 1916, the line started its carload freight operation between South Bend and Chicago at night with a motorcar and one standard freight car. Its steam railroad standards with fairly straight trackage made it possible. The first freight station was an off-track boxcar at the Cummings Siding in South Bend. (Courtesy of CRA.)

Michigan City was the location of the CLS&SB corporate and operating offices as well as its maintenance shops and yards. This building on the south side of the tracks was the office of the superintendent, staff, and dispatchers; shops were on the north side of the tracks. Over the years, improvements have been made, and the facilities have expanded as needed. (Courtesy of LCHS.)

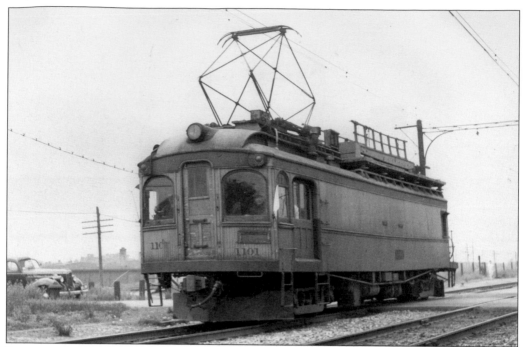

Repairs and ordinary maintenance to the overhead catenary system could not be done in the shops, so line cars were put into service. Line Car 1101 (seen here) started as a wooden combine car (no. 72), built by Niles in 1908, and was converted in 1927. In the very early years of the CLS&SB, the line car was moved up and down the tracks with a horse. (Courtesy of CRA.)

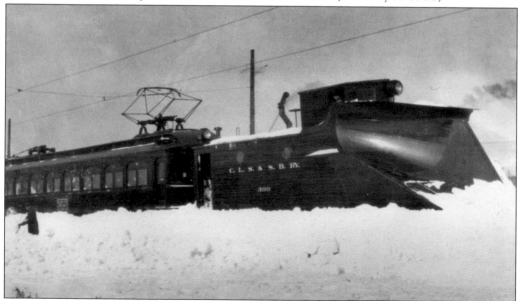

Although it looks as if it were moving snow in the middle of the Rocky Mountains, this Russell plow was attached to the front of a typical CLS&SB train in northern Indiana. Weather—heavy snow or extremely cold temperatures—always played a big role in the operation of the Lake Shore and its successor. Nature caused shutdowns in 1913, 1918, 1958, 1978, and 1982. (Courtesy of CRA.)

A coach yard and service facility were also maintained at the end of the line in South Bend at LaSalle and Hydraulic Avenues. Previously, the cars had simply been parked on the street overnight. (Courtesy of CRA.)

Simply increasing passenger and freight business was not enough in the years after World War I as the automobile became more sophisticated and cheaper to own and operate. Here, a local bus barrels down Michigan Street (the Lincoln Highway) in New Carlisle. The bus route was only two blocks from the train station, which also served the Chicago South Bend and Northern Indiana interurban. (Courtesy Historic New Carlisle.)

What's more, the Dunes Highway—US Route 12, authorized by the state of Indiana in 1920—was being built not a block south of the LS right-of-way in Porter County (lines and poles on the left). It paralleled the LS from Gary to the west side of Michigan City, where it swung north into Michigan. The Lincoln Highway in Porter County was only 10 miles away. (Courtesy Gary Public Library.)

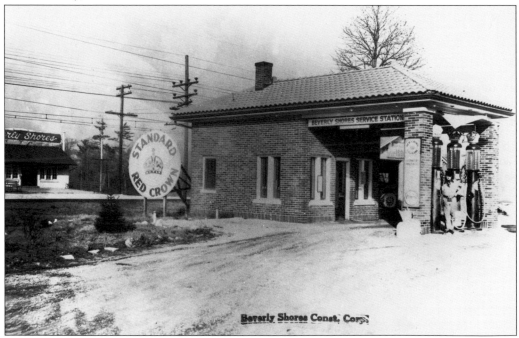

The private automobile became the must-have item in the 1920s, and gas stations like the Beverly Shores Standard Oil appeared on the Dunes Highway to serve them. In the background, across the tracks, is the Beverly Shores CLS&SB station. (Courtesy of IDNL.)

Two

WHITE KNIGHTS

On the crest of his wave of success, Samuel Insull Sr. owned or controlled just about everything related to electric utilities in Chicago and the Midwest. Like the Rockefellers of Standard Oil and the partners of US Steel, Insull felt it only made sense to expand one's holdings laterally as well as vertically. When he bought the South Shore and two other electric interurbans, he became his own best customer. However, by the early 1930s, antitrust laws and international economics caught up with him, and the South Shore found itself alone in the world once more, only to be saved by another "white knight"—World War II.

In 1911, Samuel Insull Sr. created Middle West Utilities as a holding company for all the electric, gas, and streetcar companies he had acquired in southern Indiana and Pennsylvania since 1902. Between 1911 and 1914, he became the chairman of the board of Peoples Gas Light and Coke Company in Illinois and acquired the Metropolitan Elevated Railway Company, Chicago's elevated railroad system. Commonwealth Edison of Illinois, also an Insull company, owned about 80 percent of the common stock of the "L's," which meant that it owned its largest customer. By the time Middle West was broken up in the 1930s, it served 5,000 communities in 32 states. In 1923, Public Service Investment Company was created as a holding company for all the northern Indiana utilities. It soon changed its name to Midland Utilities and was the entity that purchased the Chicago Lake Shore and South Bend in 1925. Northern Indiana Public Service Company (NIPSCO) was also a subsidiary of Midland, as were the Chicago Aurora & Elgin and the Chicago North Shore and Milwaukee interurbans. (Courtesy of CRA.)

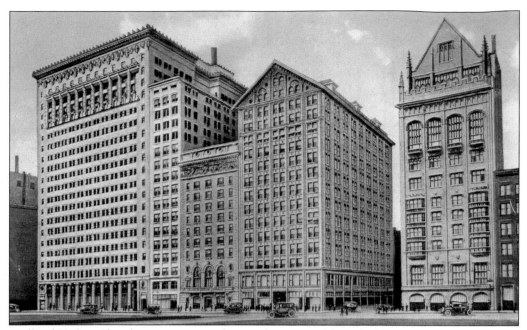

Midland Utilities' headquarters was in the Peoples Gas Building (left) facing Michigan Avenue. Across the street was Grant Park and beyond that the South Shore tracks. The other buildings are, from left to right, the Lake View, the Illinois Athletic Club, the Monroe, and the University Club. (Courtesy Max Rigot Selling Co.)

When it bought the LS, Midland Utilities renamed it the Chicago South Shore and South Bend, probably because the line was already being called the South Shore as well as to differentiate it from Midland's Chicago North Shore and Milwaukee line. New stock was issued showing the railroad's two divisions: electric passenger and freight. (Courtesy of CRA.)

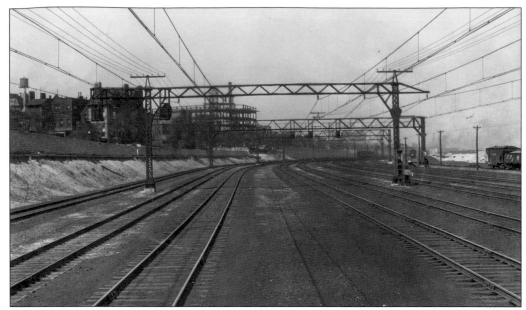

By August 1926, the Illinois Central had complied with the City of Chicago's order to electrify its suburban line, shown here around Thirty-first Street. At that time, the CSS&SB changed from alternating current (AC) to direct current (DC) in order to fit in with the IC's system. It was then able to run on its own power all the way to Randolph Street, making for a more comfortable passenger experience. (Courtesy of ICRRHS.)

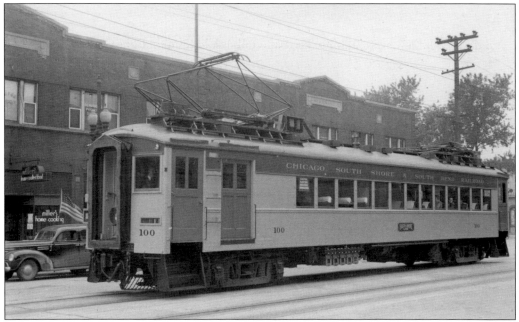

With new ownership came not only a cash infusion, but also boundless enthusiasm. New cars were ordered from the Pullman Palace Car Company. No. 100, seen here, was an all-steel combine carrying 44 passengers; full coaches seated 56. All cars had separate smoking compartments and toilet facilities. The woodwork was mahogany and the walkover seats were upholstered in green mohair velvet. (Courtesy of CRA.)

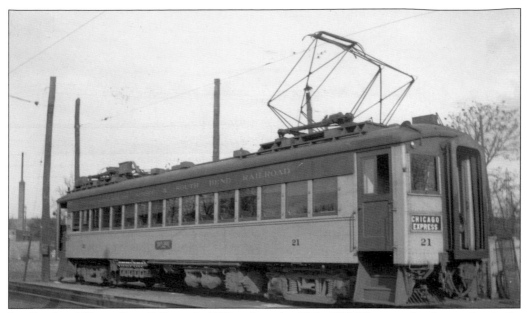

Insull ordered 25 cars from Pullman in 1926 and another 20 in 1927. The second order, mechanically almost identical to the first, was delivered in 1928, but the cars' interiors were deluxe. They featured enclosed Pullman-type smoking compartments and bucket seats that rotated and were upholstered in gray, Byzantine plush. (Courtesy of CRA.)

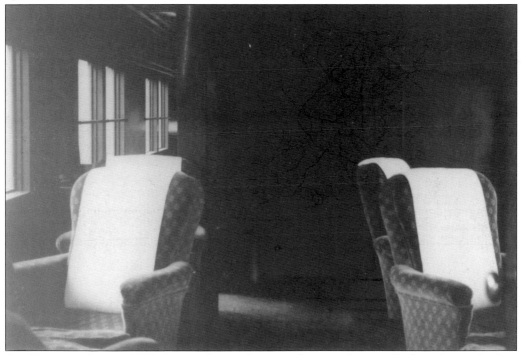

Car 21 went online in 1927 along with two dining and two parlor cars. Each parlor car had an enclosed observation/solarium at both ends. In between were separate rooms for women and men, toilets, and a refreshments bar. The dining cars served 24 passengers at tables set with linen, china, and silverware. (Courtesy of CRA.)

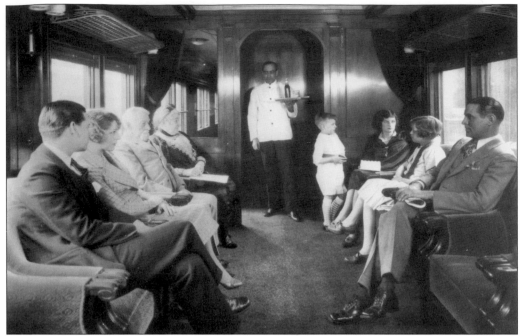

Three dining-car trains and two parlor-car trains operated in each direction on two-and-a-half-hour schedules that coincided with either breakfast, lunch, or dinner. These trains were called "limiteds" because they did not stop at every station. Such deluxe service also deserved special names. Eastbound they were the *Notre Dame*, the *Indiana*, and the *St. Joe Valley*. On the westward trip, they were the *Fort Dearborn*, the *Illinois*, and the *Garden City Limited*. (Courtesy of CRA.)

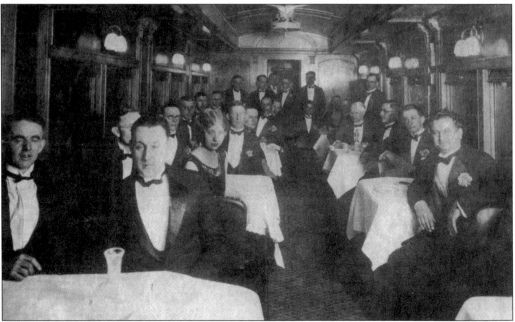

This photograph shows a dining car in action. The group being served is the Apollo Male Chorus of Minneapolis traveling between Chicago and Michigan City in 1927. The choral group was founded in 1895 and still performs around the world. (Courtesy of CRA.)

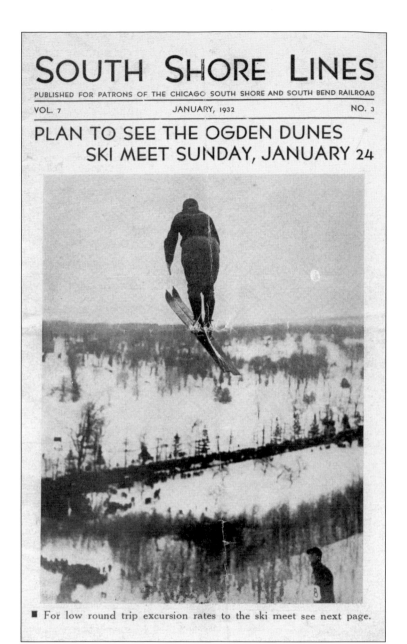

SOUTH SHORE LINES

PUBLISHED FOR PATRONS OF THE CHICAGO SOUTH SHORE AND SOUTH BEND RAILROAD

VOL. 7 JANUARY, 1932 NO. 3

PLAN TO SEE THE OGDEN DUNES SKI MEET SUNDAY, JANUARY 24

■ For low round trip excursion rates to the ski meet see next page.

Throughout its ownership of the CSS&SB, Midland Utilities publicity department churned out a variety of printed communiqués. *South Shore Lines* was an eight-page, monthly newsletter that told riders about changes in schedules as well as new excursion offerings and anecdotes about the railroad, its employees, and the areas through which it traveled. *The Pantograph* was the in-house newsletter for employees. Another prominent publication was a booklet called *First and Fastest*, which was published in 1929. It described the line's record during the four years it had been under Insull's care, moving "figuratively from the scrap heap to the front rank among the electric railways of America." It won several awards along the way. The ski jump featured on the cover of this edition of the *South Shore Lines* was located in Ogden Dunes between 1927 and 1932. At 500 feet long and 30 stories tall, it was considered the nation's highest jump at the time. (Courtesy of CRA.)

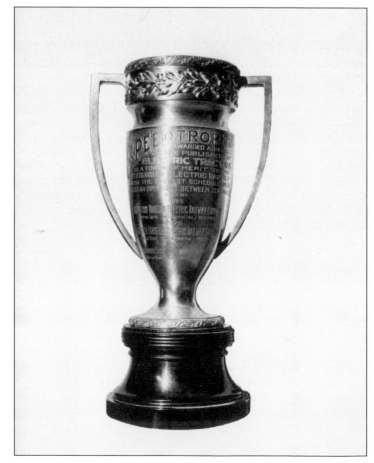

The Coffin Prize was given to the SS in 1929 for its "distinguished contribution to the development of electric railway transportation for the convenience of the public and the benefit of the industry." An additional $1,000 cash prize was to be used for the benefit of the employees. General Electric first offered this prize in 1922 in honor of Charles A. Coffin, its founder. (Author's collection.)

The Interurban Speed Trophy was awarded by *Electric Traction* magazine and the American Electric Railway Association to the SS in 1929 because it had been the fastest of 22 regularly scheduled electric interurban railways in the United States and Canada in 1928. That year, it averaged 45 miles per hour between Chicago and South Bend. The trophy was a silver loving cup engraved with the details of the prize. (Author's collection.)

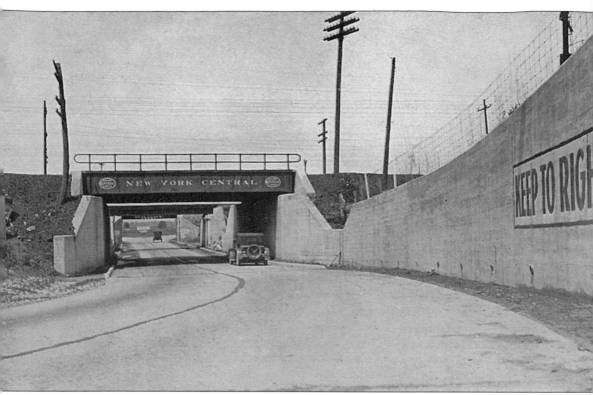

The South Shore had its ups and downs in the years after World War I. In the 1920s, both private autos and over-the-road trucking firms gave the line stiff competition. This view shows the Lincoln Highway just east of New Carlisle as it passes beneath the newly constructed New York Central viaduct. It took residents of New Carlisle 10 years and the threat of an eight-mile-per-hour speed limit through town to convince the NYC to put in the safety feature eliminating the "Death Crossing." The viaduct also carried the South Shore and the CSB&NI tracks. After the stock market crash in October 1929, the South Shore began to falter. As the economy worsened, fewer passengers rode into work or to shop in Chicago, and less freight was hauled as demand for the region's manufactured goods declined. In 1932, after several court appearances, the Insull empire was dismembered, and the South Shore was once again on its own. (Courtesy of Historic New Carlisle, Inc.)

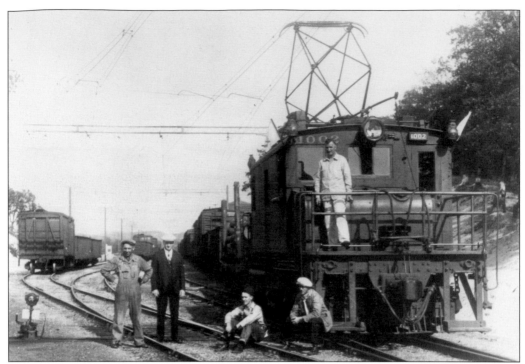

The railroad now began to tighten its belt, too, but also found a way to diversify its freight service beyond the tonnage carried for Insull companies. It also initiated "interline passenger ticketing" for travelers going beyond Chicago or South Bend. By 1940, revenues had returned to 1920s levels. (Courtesy of CRA.)

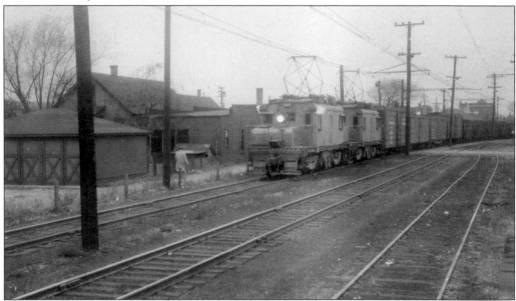

This South Shore freight train makes its way through Hammond. The Baldwin-General Electric steeple cab locomotives like this one and no. 1002 (at the top of the page) went into service in the late 1920s and early 1930s. They were not retired until the 1960s, when their 80-ton weight and "interurban style" became less useful. (Courtesy of CRA.)

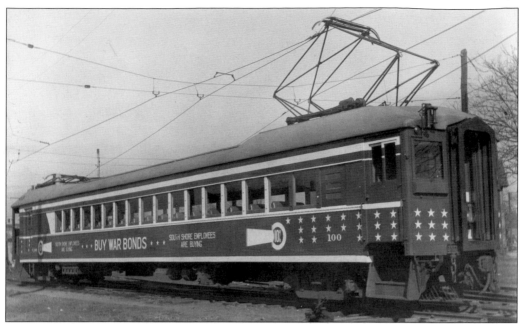

During World War II, passenger numbers increased so dramatically that the company had to lengthen several cars; car 15 was the first. In 1942, at the Michigan City shops, it was cut in half to receive a 17-foot, six-inch middle section, giving it 80 seats instead of 56. On the exterior, the South Shore's orange and mahogany paint sections were reversed. (Courtesy of CRA.)

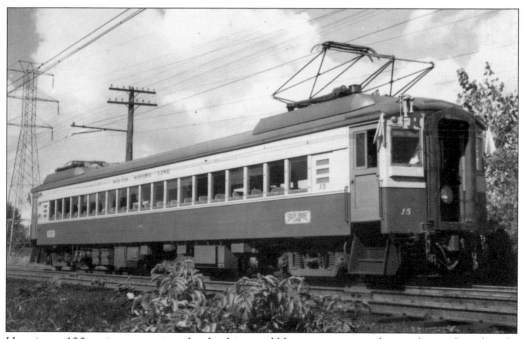

Here is car 100 again, now painted red, white, and blue to encourage the purchase of war bonds. In 1943, it was one of the first combines to be lengthened. In 1945, the South Shore carried over six million passengers—a number never experienced before or since. (Courtesy of CRA.)

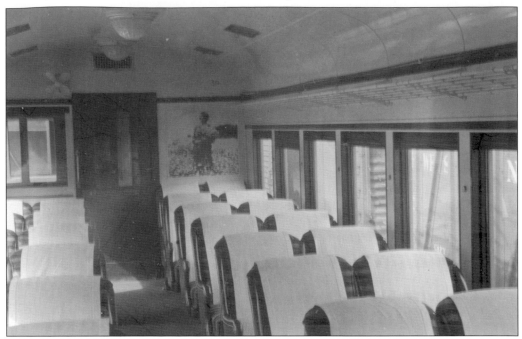

The interiors of the lengthened cars also changed. New materials that were more utilitarian were used to upholster the seats, and fixed picture windows replaced operable windows in some of the cars. Some cars were also fitted with air-conditioning units. In those that were not, passengers rode with open windows for many summers to come. One detail of the lengthened cars was the addition of mirrors or murals on the end walls. The murals were created with inlaid pieces of linoleum in the Michigan City shops. Although some of the cars may have changed, the stations, with a few exceptions, remained much the way they were when Midland Utilities remodeled or rebuilt them in the late 1920s. (Courtesy of CRA.)

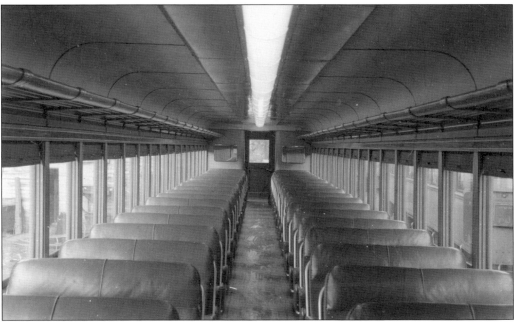

Three

HISTORIC DEPOTS
OF THE SOUTH SHORE LINE

The CSS&SB interurban used a variety of station styles and building materials over its 90-mile run. Except for the six Illinois Central stations in Chicago, the layouts were typically utilitarian rooms or roofed outdoor platforms, primarily used for waiting. An in-town South Shore depot usually occupied a storefront because the trains ran on the street. All baggage and express material was wheeled out on a standard railroad baggage car and loaded onto the train while passengers boarded. Such a station may also have provided restrooms as well as a ticket agent and snack bar. In some instances, office space and living quarters for the agent were included. The South Shore also built two-story brick substations every 6 to 10 miles. Inside these buildings, rotors stepped down and converted electric power from alternating current (AC) to direct current (DC) and then fed it to the trains through the catenary system.

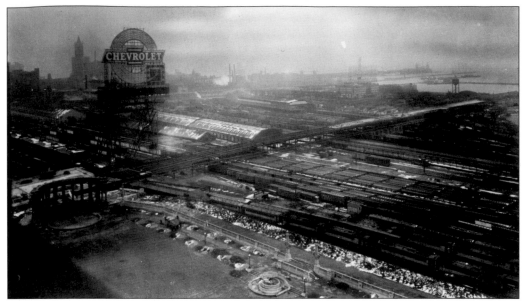

Watching the sun break through clouds over Grant Park and the IC yards, it would have been difficult to believe that the stock market had crashed and Sam Insull's holdings were decimated. The area in the left foreground was in the midst of a reconstruction project that not only provided a new SS station, but it also extended Randolph Street east to the future Lake Shore Drive. (Courtesy of ICRRHS.)

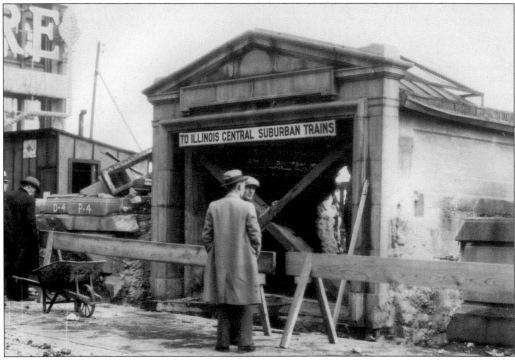

One of the first structures to go was the entrance to the IC station on the east side of Michigan Avenue where Randolph Street ended. The station had a history reaching back to the 1850s and had been redesigned and rebuilt three times already. (Courtesy of ICRRHS.)

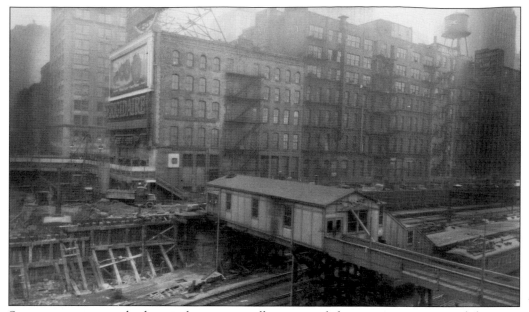

Soon, commuters on both train lines were walking around the construction site and down an open flight of stairs to the temporary station, which they left to stand on open platforms to wait for their trains. South Shore cars arrived and departed on the tracks below and to the right of the station. (Courtesy of ICRRHS.)

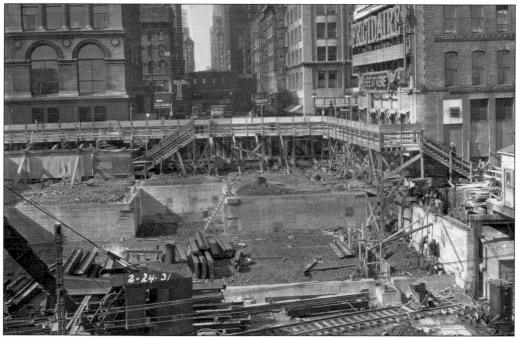

"Sidewalk superintendents" must have enjoyed themselves tremendously trying to figure out who was doing what in the big hole at the east end of Randolph Street. The hole remained open for two years as the project was held up in the Chicago City Council. On the left is the former public library, and in the distance is the Randolph and Wabash Street elevated station. (Courtesy of ICRRHS.)

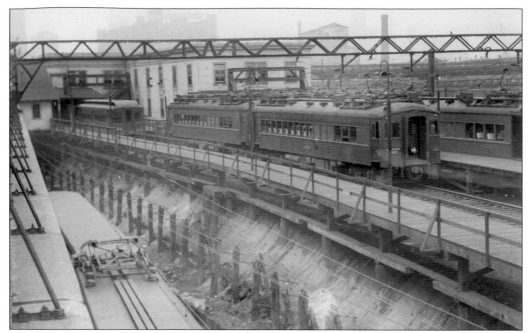

Around the time the Randolph Street Station was remodeled, the South Shore depot was the little frame building on the left. Below it on the left is an IC train heading into the station underground. The wooden South Shore station and platforms suffered fire damage at least three times. (Courtesy of ICRRHS.)

Looking up from the new underground track shed at Randolph Street, the South Shore motormen and curious passengers could see the superstructure of the station floor, the "bottom" of Grant Park, and the Randolph Street viaduct that would connect Michigan Avenue with Lake Shore Drive over the remaining railroad yards and piers that fronted the Chicago River. (Courtesy of ICRRHS.)

Looking inbound to the left is an IC commuter train. The tracks in the foreground would be used by the South Shore. A bit of the viaduct superstructure is in the upper right. (Courtesy of ICRRHS.)

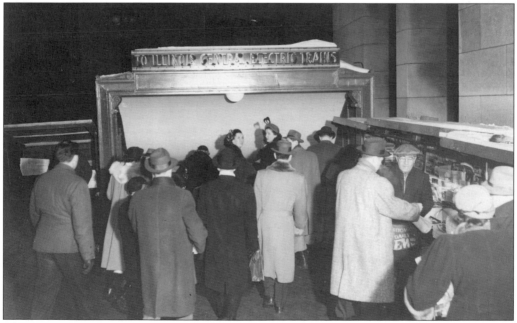

The current entrance at street level is in the same location today as it was when it was designed in the late 1930s or early 1940s at the northeast corner of the Chicago Public Library (now the Chicago Cultural Center). Later, the newsstand was moved to the west side of the Randolph Street entrance to the library. (Courtesy of ICRRHS.)

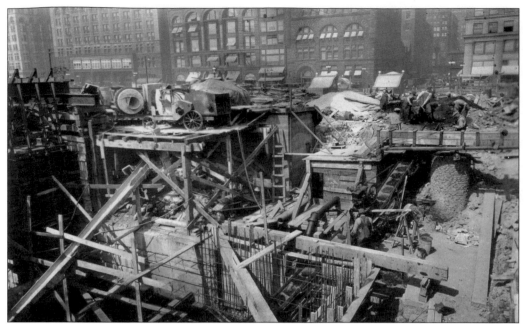

Farther south, the Van Buren Street Station was also undergoing reconstruction. The predecessor to the current station was a small, octagonal building with an open veranda in Lake Front Park (now Grant Park). It was replaced in 1896 by the current station. In the background are the slanted roofs of its street-level entrances. Behind them are the Fine Arts Building and Orchestra Hall on Michigan Avenue. (Courtesy of ICRRHS.)

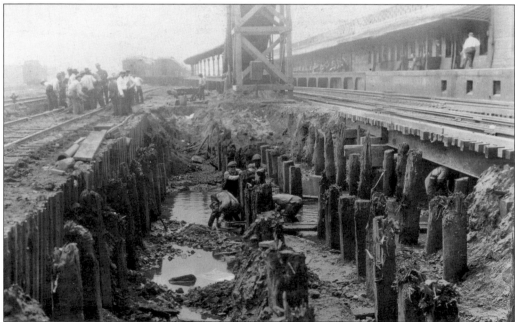

Since the Illinois Central had filled in many square acres of Lake Michigan, its track bed was moved from a trestle to landfill in time for the World's Columbian Exposition. The trackside entrance to the station, still in use today, is on the right. Above the station is a parapet, and beyond that is Grant Park. (Courtesy of ICRRHS.)

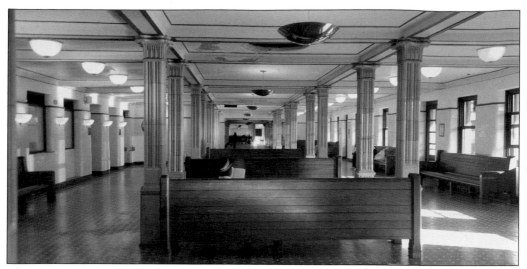

The Van Buren Station was designed the way many Chicago architects had hoped that the Columbian Exposition buildings would be: in the Chicago School style. The interior of the station is full of Sullivanesque details like foliage, terra-cotta facing on the columns, patterned ceramic tile flooring, and rounded corners. The colors cream, maroon, and brown were predominant in the 100-year-old waiting room, which was restored in the late 20th century. (Courtesy of Robert E. Pence.)

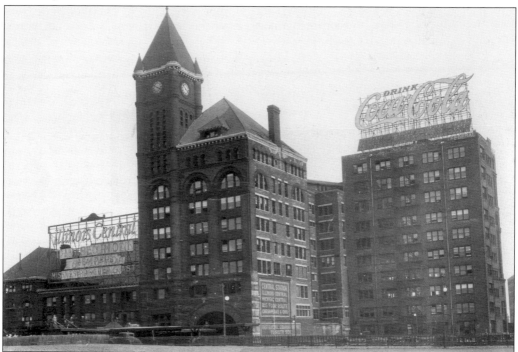

Known to South Shore commuters as the Twelfth Street Station and later called Roosevelt Road by conductors, this was also Central Station, the northern terminus of the IC's "fabled main line of Mid-America." Its clock tower, and later the neon "Illinois Central" and "Coca-Cola" signs, were trackside landmarks. IC and CSS&SB commuters used exterior platforms located to the left on the lakefront side of the station. (Courtesy of ICRRHS.)

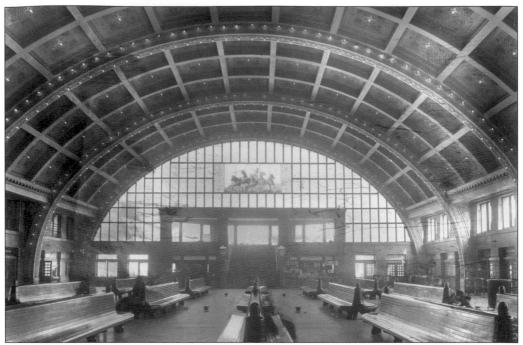

Inside, there was a grand staircase and a vaulted waiting room that straddled the tracks. The station was built in 1893 to serve visitors to the World's Columbian Exposition held farther south on the IC line at Hyde Park. Architect Bradford L. Gilbert of New York designed it. It was demolished by the mid-1970s. (Courtesy of ICRRHS.)

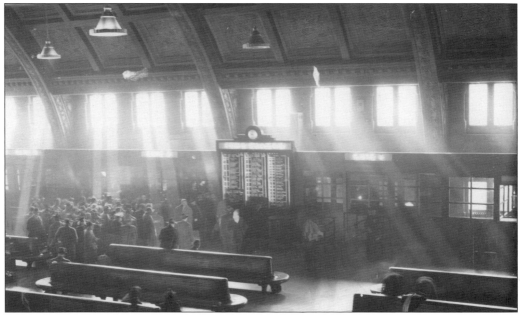

The steam long-haul passenger trains, which were later diesel, arrived and departed here. The IC shared the premises with the Michigan Central, Big Four, and B&O Railroads as well as New York Central subsidiaries like the Michigan Central, Wisconsin Central, Chesapeake & Ohio, and the Soo. (Courtesy of ICRRHS.)

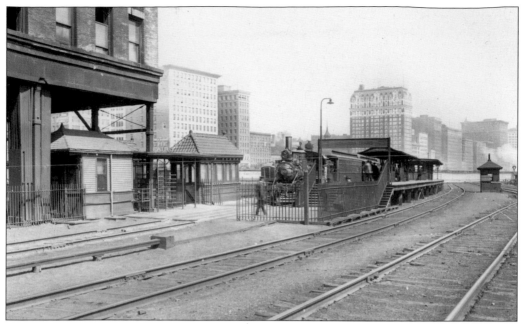

The commuter platform, seen here, was on the east side of Central Station. The turnstile gate and ticket office is to the left. Lake Front Park (now Grant Park) is beyond Park Row, a street that ran behind the locomotive and platforms. Gen. George B. McClellan of Civil War fame lived at One Park Row during his tenure as vice president of the Illinois Central Railroad. (Courtesy of ICRRHS.)

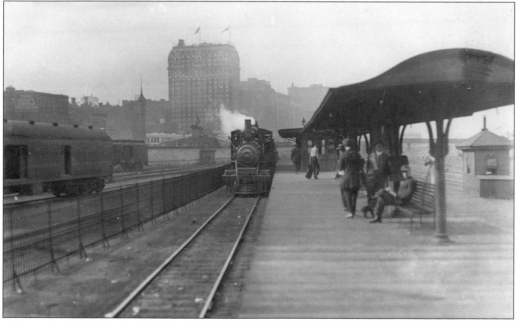

This is another view of the ground-level platform of the Twelfth Street (or Central) Station, with its sloping roof. The photograph was taken before the Illinois Central went electric. In the background is the Blackstone Hotel, the scene of many political conventions through the years. (Courtesy of ICRRHS.)

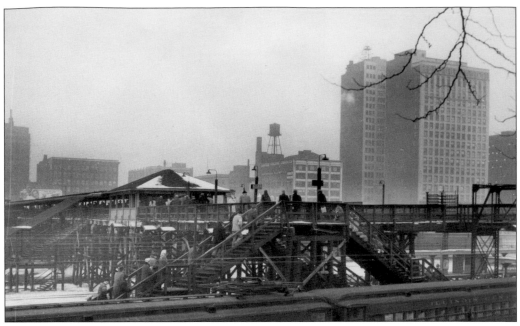

This is the later Twelfth Street Station that most 20th-century commuters remember. Trains came in below, at ground level, and passengers, braving whatever nature had in store for them, had to climb up and walk over to reach Michigan Avenue or turn in the opposite direction to reach the Shedd Aquarium and the planetarium on the lakeshore. (Courtesy of ICRRHS.)

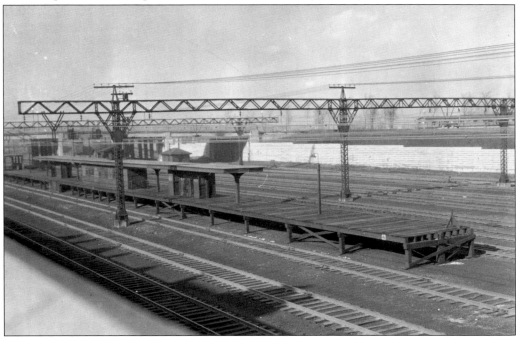

The Lake Shore and the South Shore used only six of the IC stations in Chicago. With a few short-lived exceptions—Seventy-fifth and Forty-third Streets and a later permanent stop at Twenty-second Street—they are the same today. This platform at Thirty-first Street was typical of the stations the South Shore "flew" past. (Courtesy of ICRRHS.)

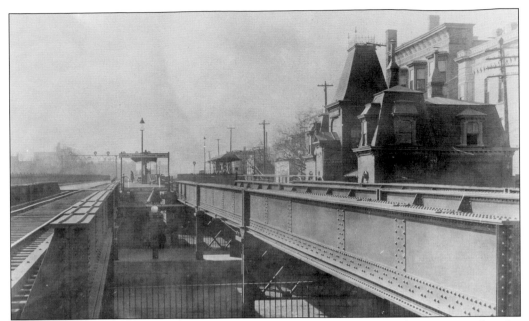

The Fifty-third Street Station, finished in 1875, was designed by H.M. Wilcox. Fearing that the IC would put up an ugly building, the residents of Hyde Park financed the project themselves. Although it survived the elevation of the tracks between Forty-seventh and Seventieth Streets preceding the 1893 World's Fair in Jackson Park east of the station, steel girders detracted from its former air of genteel welcome. (Courtesy of ICRRHS.)

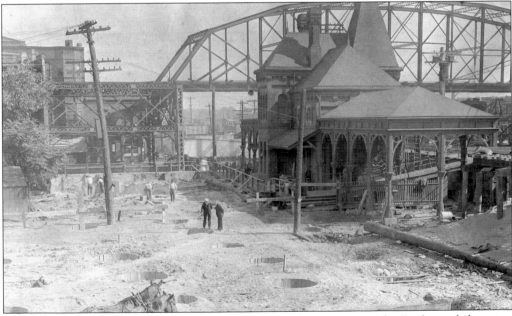

The brick Sixty-third Street/Woodlawn Station was the gateway to the Englewood shopping district. At one time, the stationmaster and his family had quarters on the second floor. Here, the CSS&SB, running side by side with the electric IC, also crossed two other electric lines: the Sixty-third Street streetcar and the Jackson Park elevated, which ran on the bridge behind the station. (Courtesy of ICRRHS.)

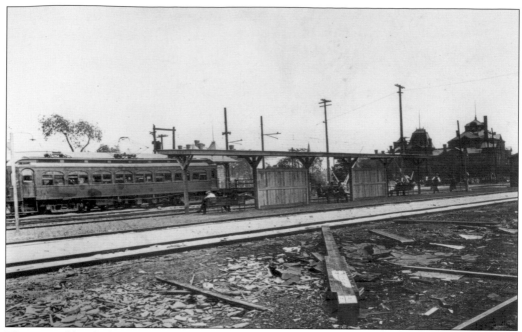

The ground-level platform at Pullman, with the 111th Street gates and crossing behind and to the right, was the transfer point for the CLS&SB after the K&E line was built. Passengers would leave one of the Lake Shore's Niles cars, seen here, to walk back (on the right) to stairs that led to a covered bridge over the tracks and down the stairs to a waiting Illinois Central steam train. (Courtesy of CRA.)

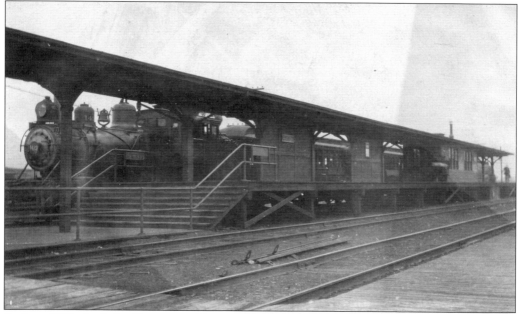

By June 1912, the Lake Shore was able to approach the on-grade platform at Kensington/115th Street Station on its own. The Lake Shore's electric cars were then attached to a steam engine for the rest of the trip into downtown Chicago. It was a much more convenient system for the passengers, but it still delayed the trip by many minutes. (Courtesy of CRA.)

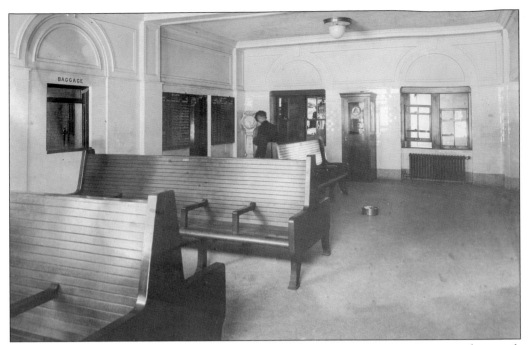

A new Kensington Station was built in 1918 as part of the IC renovation to accommodate track elevation and conversion to electric service for its commuter line. This is the interior of the building that was entered at street level via Front Street. Baggage was hauled up to the platform by an elevator reached through the door marked "baggage." (Courtesy of ICRRHS.)

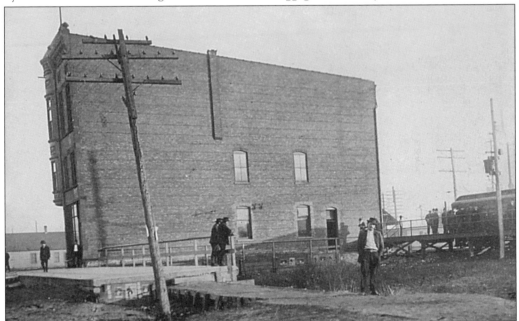

Eastbound south of Lake Calumet, the South Shore passed flag stops at 124th Street, Parsons, the 130th Street Bridge, Calumet Harbor, Ford City, and for a few years after World War II at Altgeld Gardens. The first scheduled stop was Hegewisch, a Chicago neighborhood with its station at the back of a three-story building on Brainard Avenue near Brandon Avenue. (Courtesy of SCHS.)

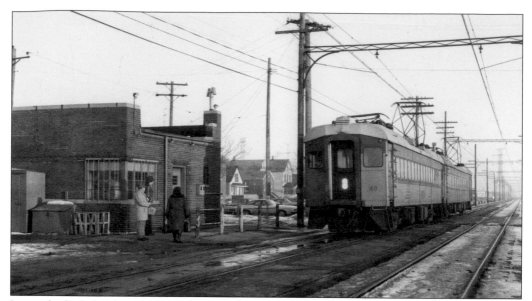

Later, the little brick station seen here was built on the same site. It was designed by Kenneth R. Vaughn of Hammond, Indiana, in 1945. Over the years, more and more automobile parking was added for commuters' convenience. Through Hegewisch and Burnham, the South Shore ran on the Kensington & Eastern Railroad, which it leased from the Illinois Central. (Courtesy of CRA.)

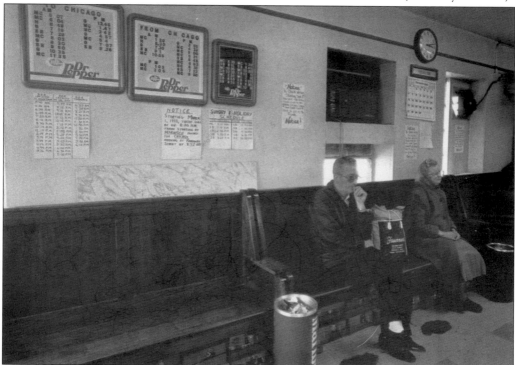

Inside the Hegewisch Station was a functional waiting room with a marble-topped lunch counter across from the benches. Restrooms, telephone booths, and a ticket office were on either side of the rear door that led to the tracks. The concession owner who ran the lunch counter and newsstand also kept geraniums in the front windows. (Author's collection.)

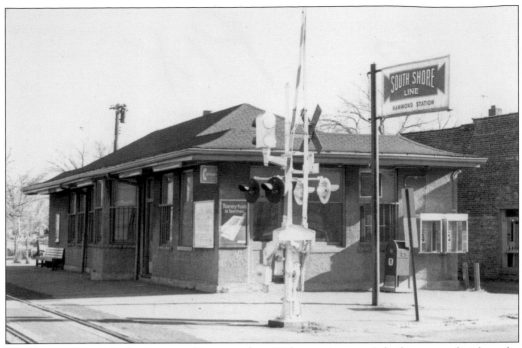

The first station in Indiana was at Hammond on Hohman Avenue. It had a stucco finish and a polygonal operator's bay. In its heyday, it offered travelers a lunch counter as well as restrooms, a waiting area, and a live ticket agent. The next station, at East Chicago, was a storefront on Chicago Avenue near Indianapolis Boulevard (formerly Forsyth Avenue), which was later home to Sarti's Restaurant. (Courtesy of CRA.)

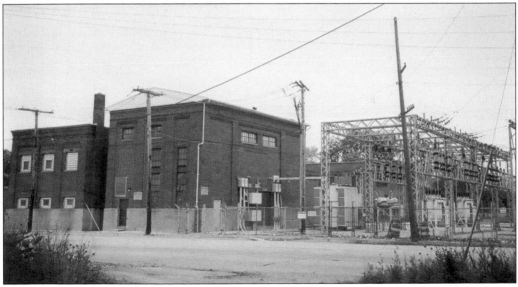

The Columbia substation is near the 1956 East Chicago station. Substations were built every six miles or so along the line. They serve to step down the power, which originates at the generating plant, and transmit it to the trains through the catenaries and pantographs. Other substations are at Hegewisch, Ogden Dunes, Tremont, Tee Lake, and New Carlisle. In emergencies, portable substations can be brought in. (Author's collection.)

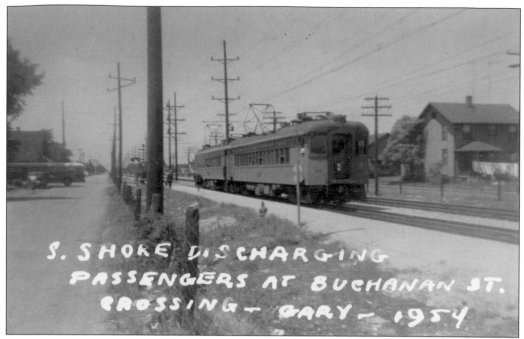

S. SHORE DISCHARGING PASSENGERS AT BUCHANAN ST. CROSSING — GARY — 1954

Buchanon Street, like Ambridge Avenue and Clark Road in Gary along Third Avenue, was a flag stop. Although there was no sheltered waiting facility, passengers did not have far to walk to their houses. This type of stop was widely used by all interurbans, but it was more often found out in the country. (Courtesy of CRA.)

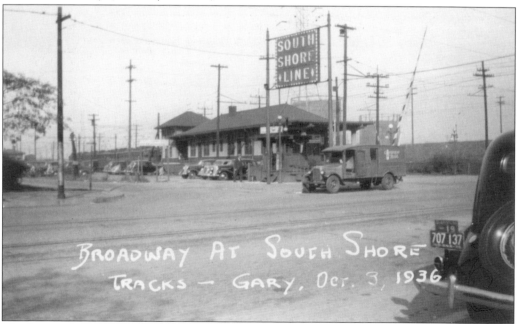

BROADWAY AT SOUTH SHORE TRACKS — GARY, Oct. 3, 1936

The first station in downtown Gary on Broadway and Third Avenue was built in 1908. It was brick with a tile roof. The location was convenient to the US Steel plant, beyond the embankment, as well as to the county and municipal buildings a block or two in the other direction on Broadway. This is the second station in Gary as it looked in the 1950s. (Courtesy of CRA.)

Miller has been a scheduled stop since the days of the Chicago Lake Shore and South Bend. This is the view westbound along the tracks from the frame station around 1930. To the left is the Dunes Highway (now US Routes 12 and 20). This was also the crossing of the CSS&SB with the Miller or Gary Railway streetcar line that was abandoned in the mid-1930s. (Courtesy of LCHS.)

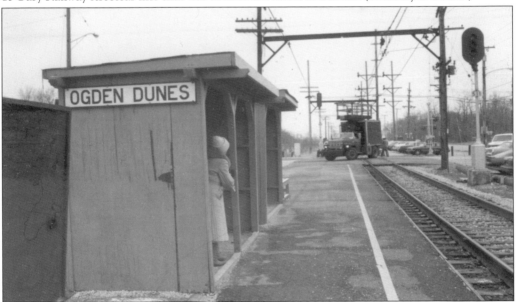

Ogden Dunes, once known as Wycliffe, has been a scheduled stop since the mid-1920s, but it has always been served by a shelter rather than a station building. Painted orange, this was a mid-20th century shelter. The crossing in the distance is Hillcrest Road, the entrance to town. One of these shelters was saved, repainted, and installed in an Ogden Dunes park. (Courtesy of Peter Youngman.)

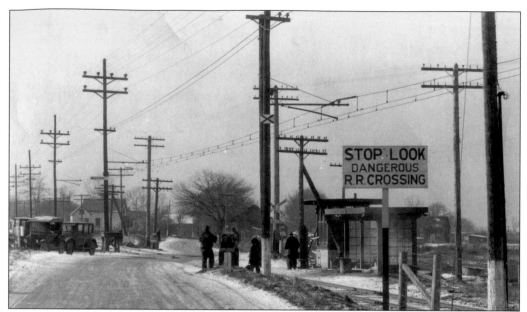

After Ogden Dunes came the Wilson stop and then Baillytown on the north side of US 12, shown here with another version of the shelter. It was indeed a dangerous crossing as the LS&MS tracks were laid at right angles through the intersection. The next stops were Mineral Springs and then Port Chester, neither of which had a station. Baillytown is known today as Burns Harbor. (Courtesy Gary Public Library.)

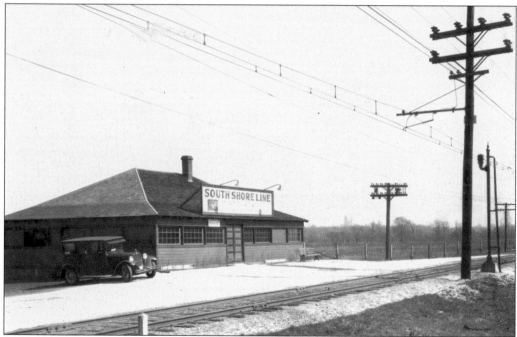

Tremont was the stop for the Dunes beaches and later the entrance to the Indiana Dunes State Park. It was a full-service station, meaning it had a ticket office and baggage room plus food service and restrooms. Passengers alighting at Tremont walked to the dunes either to spend a day at the beach or down paths through the scrub to their summer homes. (Courtesy of IDNL.)

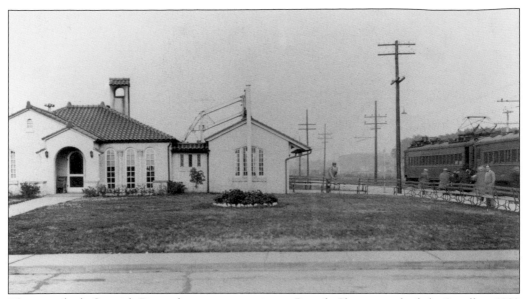

This cute little Spanish Revival passenger station at Beverly Shores was built by Insull in 1929 in the manner of several stations on his Chicago North Shore and Milwaukee line. It also had a twin at the time, located farther east at Central Avenue in Pines. Restored in 1998 and placed on the National Register of Historic Places, the station is still a flag stop, meaning that there is no regularly scheduled service. (Courtesy of IDNL.)

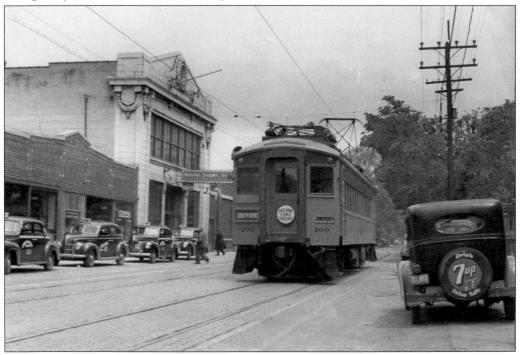

The Eleventh Street Station opened in Michigan City in May 1927 between Franklin and Pine Streets at a cost of $200,000. Designed by the railroad's engineering staff, the two-story storefront building had a terra-cotta façade and neoclassical details. It was the longest survivor of the rail line's storefront urban depots, finally closing in 1986. (Courtesy of CRA.)

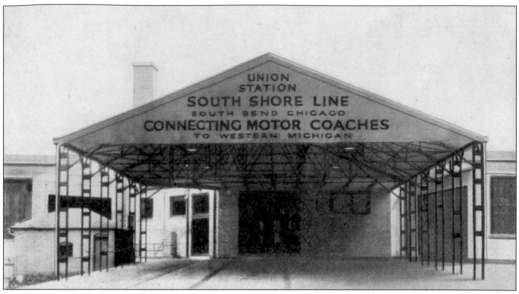

At the rear of the Eleventh Street Station was the depot for the Shore Line Motor Coach service. The CSS&SB entered the bus business to develop feeders for the rail line in 1925. A motor coach left Michigan City every hour for "the greatest summer playground in the middle west," also known as southwestern Michigan. Later, the line was extended as far north as Grand Rapids. (Courtesy of CRA.)

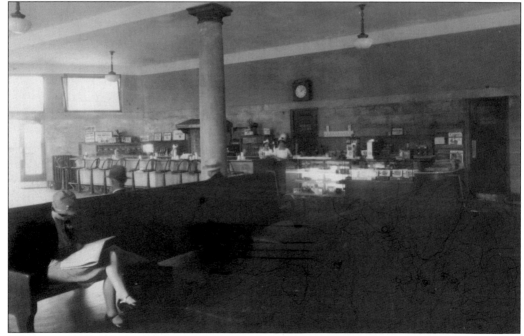

The station offered a men's smoking room, a ladies' lounge, a luncheonette (seen here), and a baggage room. Interior columns were faced with marble, while oak trimmed the windows and doorways. Offices, a meeting room, showers, and locker rooms were available for the rail line's employees on the second floor. The Shore Line's maintenance facility and garage was east of the station. (Courtesy Northern Indiana Center for History.)

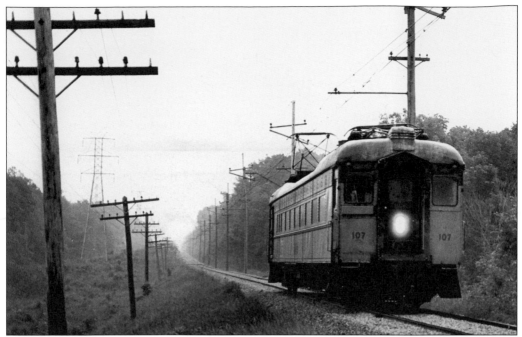

East of Michigan City, the train traveled through rural LaPorte County to Hudson Lake. Flag stops along the way included at various times Springville, Wilhelm, Lalumiere, Tee Lake, Smith, Birchim/Rolling Prairie, Hillside, Liberty Bell, and Sagaunay. This photograph of a one-car train was taken in the vicinity of Fail Road and the Smith and Birchim stops. (Courtesy of LCHS.)

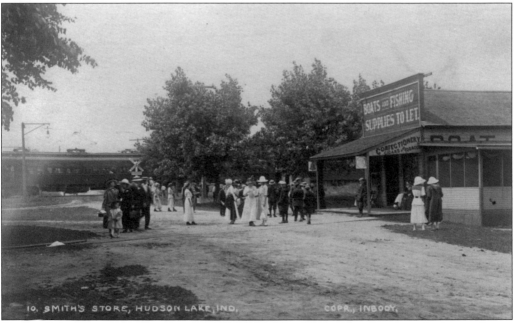

Hudson Lake, a very popular summer resort and weekend dance spot, has never had more than a shelter for passengers. In the early days of the line, travelers bought tickets and waited in Smith's store, which was close to the tracks and the hotel. These people seem to be new arrivals in town, having just alighted from the Lake Shore behind them. (Courtesy Historic New Carlisle, Inc.)

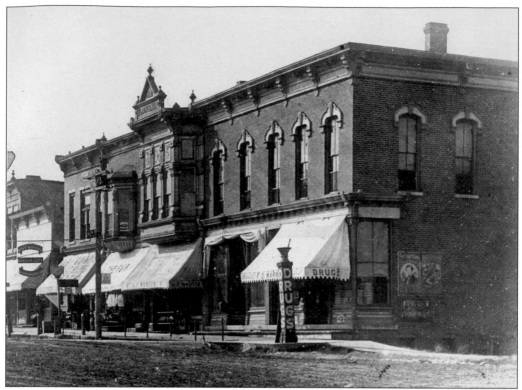

To board the train at New Carlisle, passengers purchased their tickets at the F.D. Warner drugstore, which was established in 1874 on the corner of Michigan Avenue and Arch Street, before walking down Arch to the station at the bottom of the hill. Known later as Watson's Drug (1949), the building also housed a grocery, a post office, a shoe store, and the Masonic Temple on the second floor. (Courtesy Historic New Carlisle, Inc.)

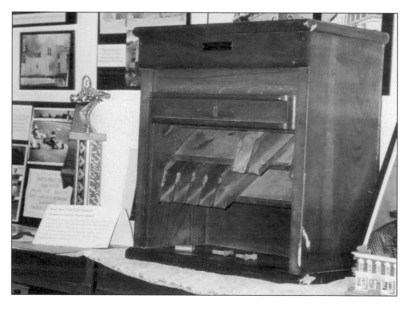

This wooden roll-top ticket dispenser from Warner's/Watson's store was discovered in the 1980s and donated to the Historic New Carlisle museum. On the bottom shelf are three wooden stamps, each with names of destinations. In its day, the dispenser was kept on the counter next to the cash register at the front of the store. (Author's collection.)

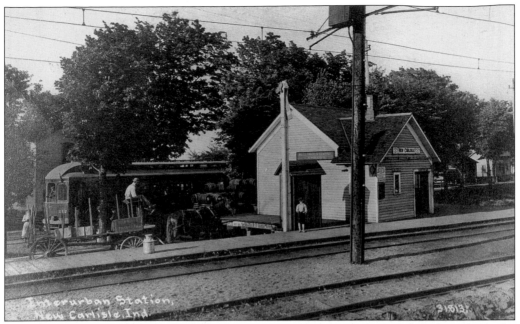

The interurban station down the hill from Warner's drugstore served passengers on both the CSS&SB and the Chicago South Bend and Northern Indiana Railway (NIRR). The NIRR, which originated in Michigan City, built the station. Its route was shorter than the CSS&SB's, as it shuttled passengers only between Michigan City and South Bend via LaPorte and Rolling Prairie. (Courtesy Historic New Carlisle, Inc.)

The South Shore has had five South Bend stations. The first, the hotel on Main Street seen here, was close to the Oliver Theater and the JMS Building. The second was a storefront on Michigan Street. For some 50 years, the third was a former Masonic Temple on the corner of LaSalle and Michigan Avenues convenient to the popular LaSalle Hotel, city and county buildings, and other public transportation hubs. (Courtesy of CRA.)

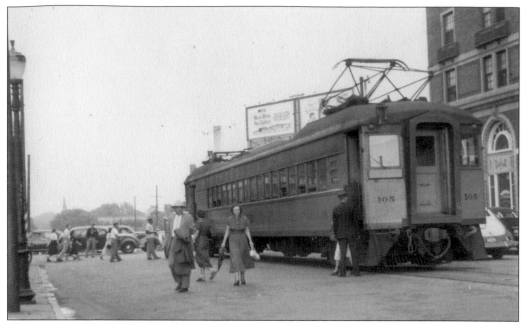

The station at LaSalle and Michigan Avenues was enlarged and remodeled in 1928 to resemble the new station in Michigan City. It offered all the full-service station amenities: ticket agent, waiting rooms, restrooms, and food concessions. It also housed a branch of the downtown Chicago Information Bureau that offered travel brochures and tips on buying property in northwest Indiana along the South Shore line. (Courtesy of CRA.)

By 1970, the City of South Bend had finally convinced the CSS&SB to remove its tracks from city streets. The fourth station was built west of town on Washington Street near the Bendix plant. The cement block building also served as waiting room for Amtrak passengers. This location made it more difficult, however, for travelers to reach recreational and business destinations in downtown South Bend. (Courtesy of CRA.)

Four

PROMOTIONS AND EXCURSIONS BEFORE WORLD WAR II

Sam Insull actively promoted his railroad and once said, "I am a great believer in publicity. I believe it is our duty to the properties we manage, to the stockholders who own them, and to the communities they serve, that we should enlighten those communities on the situation." So, in an office at 72 West Adams Street, the railroad maintained an Outing and Recreation Bureau, a Public Speaking Bureau, and an Own Your Own Home Bureau. Their purpose was to drum up leisure, residential, and industrial interest in the South Shore corridor by actively seeking excursion business, providing information about building a house or relocating a business, and sending out trained speakers with movies and slide shows about the railroad and the sites to see along the route. Brochures, advertising, and a steady stream of press releases supported the bureaus, but the most memorable of the advertising ploys were the South Shore posters commissioned by Midland to entice the public into visiting northwest Indiana.

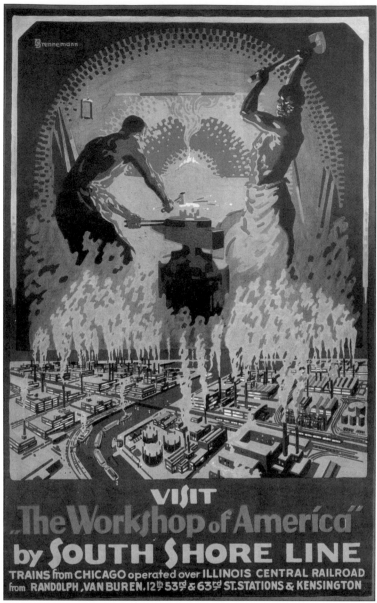

Middle West Utilities already had a foothold in northwest Indiana, so Insull and his staff were well aware of the financial potential of the Calumet region, which had been opened in 1875 and had never stopped growing. Within a short period, the CSS&SB's freight line made connections with 13 other railroads throughout northwest Indiana and south Chicago. Under Insull management, the CSS&SB worked with various entities in the region to promote the development of its industrial and residential property. To facilitate this effort, the company also commissioned artists to produce full-color posters. *The Workshop of America* was created by Otto Brennemann in 1926. Brennemann also designed posters for Insull's North Shore line and the Chicago transit system. Since convincing manufacturers to locate along the SS line was good business for the railroad, the South Shore and other Midland companies also contributed to a loan fund that aided firms moving to the Calumet if they would locate somewhere on the line so the SS could serve them. (Author's collection.)

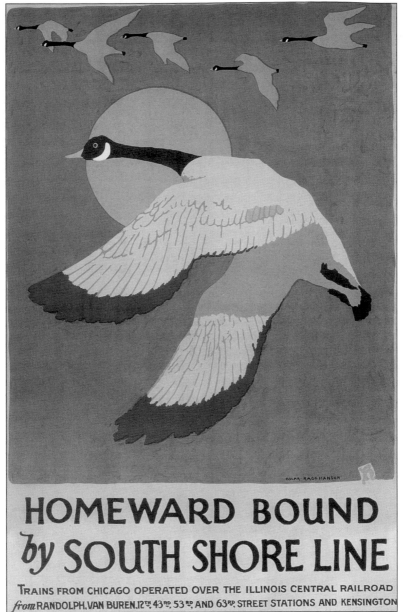

HOMEWARD BOUND
by **SOUTH SHORE LINE**

TRAINS FROM CHICAGO OPERATED OVER THE ILLINOIS CENTRAL RAILROAD
from RANDOLPH, VAN BUREN, 12TH, 43RD, 53RD, AND 63RD STREET STATIONS AND KENSINGTON

The flip side of the business-oriented poster was another work of art that reminded passengers that if they lived along the line, they would soon be home. *Homeward Bound* was the work of Oscar Rake Hanson and was also commissioned in 1926. Its opposite, so to speak, was a poster called *Outward Bound by South Shore Line*, produced by Raymond Huelster in 1929, which featured seagulls flying in the opposite direction. These posters left the impression that commuting from the south shore of Lake Michigan into Chicago was just as feasible as coming into town on the North Shore or the Aurora lines, which were also operated by Midland Utilities. The trip from South Bend took approximately two hours, while it was less than half that from Gary, traditionally the eastern end of a typical commute. Any one of the posters might have appeared anywhere from Indiana schools and libraries to the South Shore stations and trains to the platforms of the Chicago Elevated Railway—another Midland subsidiary. (Author's collection.)

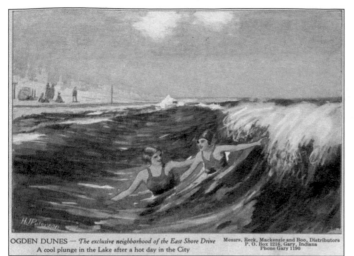

OGDEN DUNES — *The exclusive neighborhood of the East Shore Drive* Messrs. Reck, Mackenzie and Boo, Distributors
A cool plunge in the Lake after a hot day in the City P. O. Box 1216, Gary, Indiana
Phone Gary 1190

Working with the CSS&SB promotion department were the land developers of northwest Indiana. In 1923, Samuel Reck purchased the Francis Ogden estate, and with his associates, he turned most of it into Ogden Dunes. Located between the rail line and Lake Michigan a few miles east of Miller, the community was about an hour away from Chicago and a short walk into the dunes from the train. (Courtesy of Gary Public Library.)

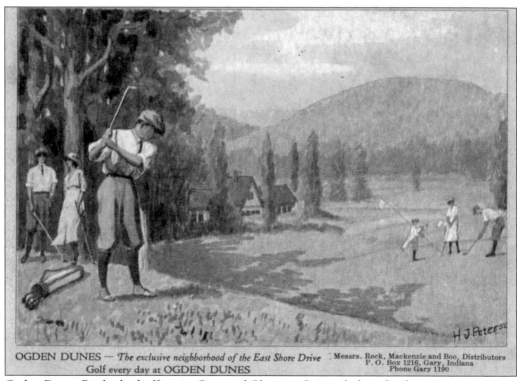

OGDEN DUNES — *The exclusive neighborhood of the East Shore Drive* : Messrs. Reck, Mackenzie and Boo, Distributors
Golf every day at OGDEN DUNES P. O. Box 1216, Gary, Indiana
Phone Gary 1190

Ogden Dunes Realty had offices in Gary and Chicago. Original plans for the resort community showed a golf course, a hotel, and a clubhouse. In 1925, there were 25 year-round residents. Between 1927 and 1932, it was home to the nation's highest ski jump on Ski Hill. The structure and athletic competitions were sponsored by the Norge Ski Club with the support of the CSS&SB. (Courtesy Gary Public Library.)

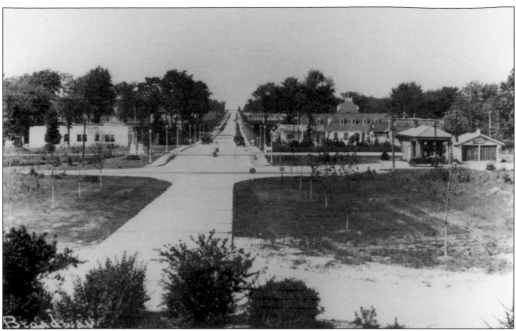

On the eastern side of Porter County was Beverly Shores, developed by Fred Bartlett to mimic the popular Spanish Revival–style resorts in Florida. Prospective homeowners were met at the Beverly Shores South Shore station (behind the gas station on the right) and driven around in a black Packard. After the showing, there was a meal, drinks, and possibly a sale before returning to the train. (Courtesy of IDNL.)

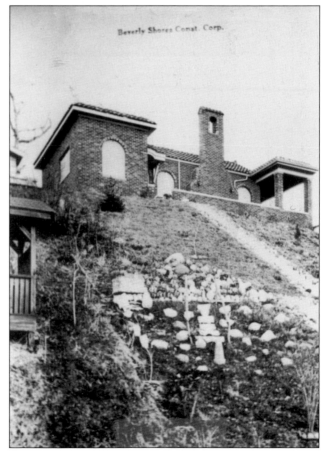

In Beverly Shores, 25 houses were built before 1935. There was also a clubhouse, a hotel, a sales office, a post office, a school, and a fire station along Broadway and Beverly Drive. Sales declined significantly as the Depression progressed, however, and after World War II Bartlett sold all of his holdings. The residents of Beverly Shores incorporated themselves as a town. (Courtesy of IDNL.)

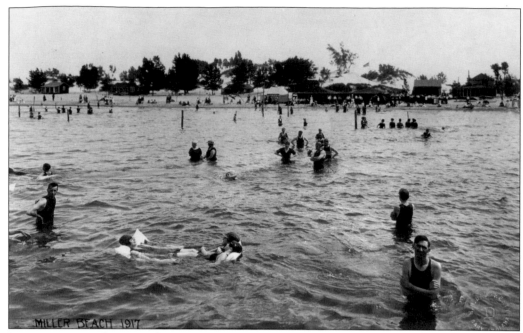

MILLER BEACH 1917

For many, it was fun enough just to take the train to Miller and walk down to the shore for a day at Carr's Beach. The area had once been the site of Octave Chanute's glider experiments in 1896. Robert and Drusilla Carr claimed it by squatters' rights and went to court with US Steel over the matter. (Courtesy of Gary Public Library.)

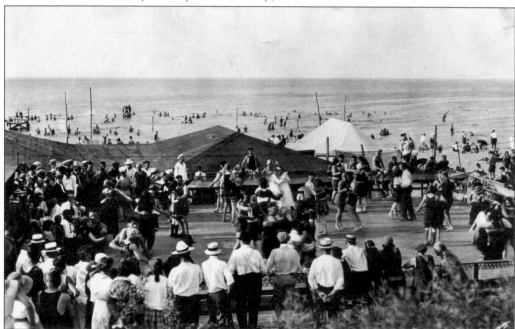

Visitors could while away the hours on an excursion boat or by visiting the miniature railroad, shooting gallery, concession stand, roller coaster, nightclubs, dance hall, or roller rink. Seasonal cottages were rented for $100 a year. The Carr's Beach bathhouse was at the foot of Lake Street. (Courtesy of Gary Public Library.)

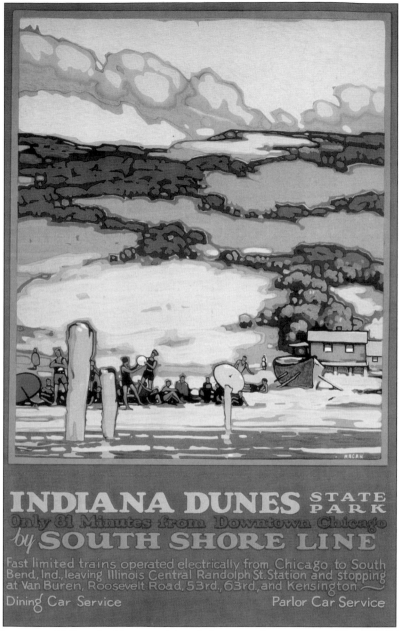

Since 1900, groups of hikers had been making their way to dune country. The CSS&SB ramped up promotion of the area with a series of posters that either highlighted outdoor activities like swimming and hiking or featured the Indiana Dunes State Park. Visitors to the dunes had been working for the preservation of that stretch of the lakeshore for 20 years when the SS became involved by donating $25,000 for the construction of the bathhouse and hotel at the park and land for the park's entrance. A never-built rail spur line, intended to connect the SS with the beach area, later became Indiana State Road 49 into the park. The state park was opened in 1925. Leslie Ragan, the creator of this 1927 lithograph, also produced one for Hudson Lake, and Emil Born contributed a poster publicizing the ski jump at Ogden Dunes in 1929. The South Shore had a good thing going, as it was the only rail line serving the dunes area. (Author's collection.)

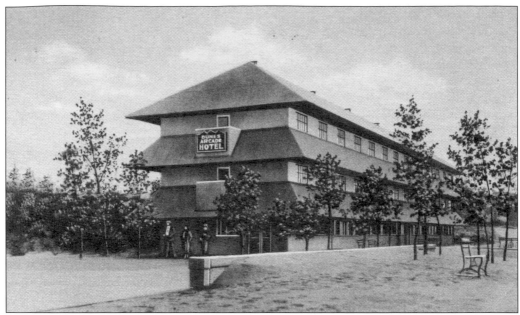

The Indiana Dunes State Park at Tremont was a popular destination. SS passengers could spend a few days at the 44-room Dunes Arcade Hotel, designed by John Lloyd Wright and opened in 1931 by the Indiana Department of Conservation. Each room had a view of the lake and the beach and had hot and cold running water and an individual radiator. Shower baths were down the hall. (Courtesy of Gary Public Library.)

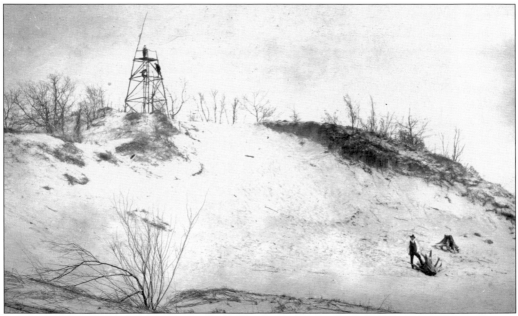

This was the observation tower on Mount Tom, 192 feet above lake level. Mount Tom was near Waverly Beach within Indiana Dunes State Park. It covered more than 100 acres and was the tallest of the "Tremonts," the others being Mount Holden (184 feet) and Mount Jackson (176 feet). The best views from Mount Tom were westward toward Gary and Chicago. (Courtesy of Gary Public Library.)

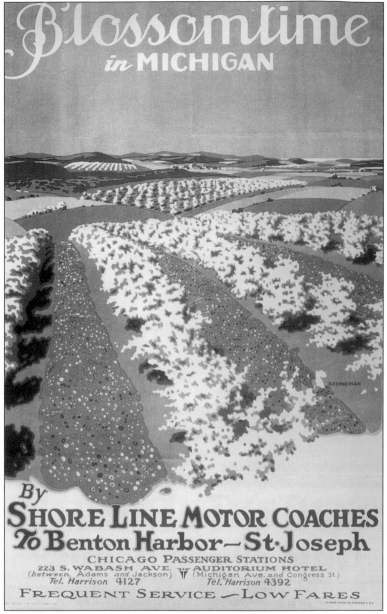

Another popular destination was southwestern Michigan. It was an easy day's travel from downtown Chicago or elsewhere on the line to the transfer point in Michigan City. The South Shore was pleased to transport people to the mineral baths at St. Joseph and Benton Harbor. There they would find relief from "overwork, lack of sunshine and air, over-eating and improper habits of various kinds." The hotels were also "splendid" places to rest during convalescence following an illness. Guests could request steam baths, hot dry-air baths, hot and cold packs, sprays, massages and corrective exercises, sunshine treatments, heat treatments, and "various forms of treatment by means of electrical energies." Besides Benton Harbor and St. Joseph seen in this South Shore poster, travelers could make connections for Grand Rapids at Michigan City and for Detroit at South Bend. Otto Brennemann was also the artist for this poster, a 1927 lithograph. (Author's collection.)

The resorts around Benton Harbor and St. Joseph, particularly Paw Paw Lake, had been attracting tourists since the 1890s. By operating its own motor-coach line to serve this area, the CSS&SB augmented its train revenues and mitigated competition from automobiles. (Courtesy of CRA.)

By the 1920s, there were 50 hotels and four dance pavilions at Paw Paw Lake. The Crystal Palace Ballroom opened in 1925 and continued to host big-name dance bands like Jimmy Dorsey and Lawrence Welk into the 1950s. The dance halls also offered game rooms and ice cream parlors to their patrons. Outdoors, there were lake excursions and an amusement park called Ellinee to keep vacationers occupied. (Author's collection.)

Excursions could run in the opposite direction as well. The Pavich family, seen here, were from Hegewisch and were among the millions who enjoyed the sights at Chicago's Century of Progress Fair staged on Northerly Island in the summers of 1933 and 1934. The fairgrounds, which were a portion of Burnham Park, extended from Twelfth Street—an easy walk from the South Shore—to Thirty-ninth Street. Later, McCormick Place was built here. (Author's collection.)

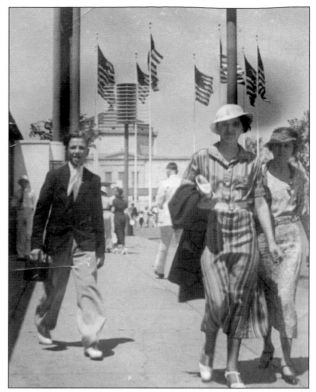

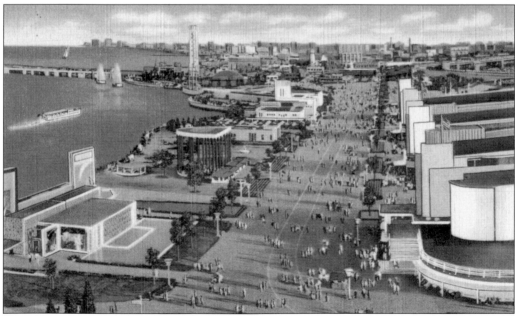

Visitors strolling the colorful Midway (below) might have stopped at any number of nightclubs and restaurants. Other attractions were scientific and industrial exhibits such as concept-car automobiles, the Union Pacific Railroad's first streamlined locomotives, and the Burlington Route's famous Zephyr train. On Gary Day, the South Shore carried over 2,500 people from Gary to the fair, including a special for the Emerson High School Band. (Courtesy of Curt Teich.)

Other things to do in downtown Chicago included trips to Navy Pier and Grant Park for festivals and concerts. And, of course, there was shopping. The South Shore brought passengers into the heart of Chicago's retail center to stores like Marshall Field's, Carson, and Pirie Scott's. The fair catered to all levels of spending, and there were a wide variety of restaurants on Randolph Street. (Courtesy of V.D. Hammon Publishing.)

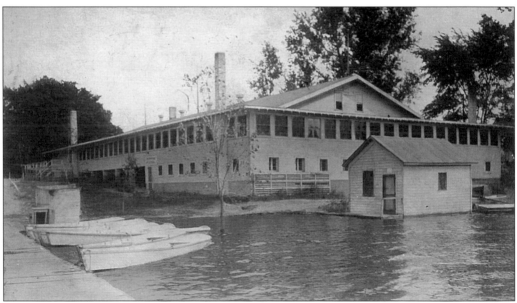

The Smith store at Hudson Lake moved in 1914 to make way for the casino, where there was live music six nights a week. It was right on the water, but there was no entrance fee; instead, couples bought dance tickets for 10¢ or six dances for 50¢. After the passing of the jazz age, the casino became a boathouse. (Courtesy of Historic New Carlisle, Inc.)

The hotel and the casino were both within a block of the SS station at Hudson Lake. Through the 1920s and early 1930s, musicians like "Bix" Beiderbecke would drive in on Saturday nights to sit in with scheduled bands like Paul Whiteman's. South Shore excursion trains brought the crowds that came to dance. (Courtesy of Historic New Carlisle, Inc.)

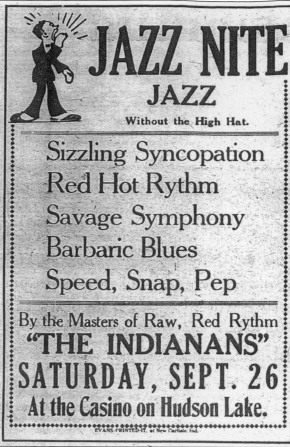

JAZZ NITE

JAZZ

Without the High Hat.

Sizzling Syncopation
Red Hot Rythm
Savage Symphony
Barbaric Blues
Speed, Snap, Pep

By the Masters of Raw, Red Rythm
"THE INDIANANS"
SATURDAY, SEPT. 26
At the Casino on Hudson Lake.

EVANS-PRINTED-IT, at New Carlisle, Ind.

Train buffs have been around for a long time. As the sign on the front of this car near Lydick indicates, it had been chartered for a group of rail fans that, even in 1938, were appreciative of the significance of the last or nearly last of the electric interurbans. East of New Carlisle, Lydick was a flag stop in St. Joseph County and the gateway to Chain O' Lakes resorts. (Courtesy of CRA.)

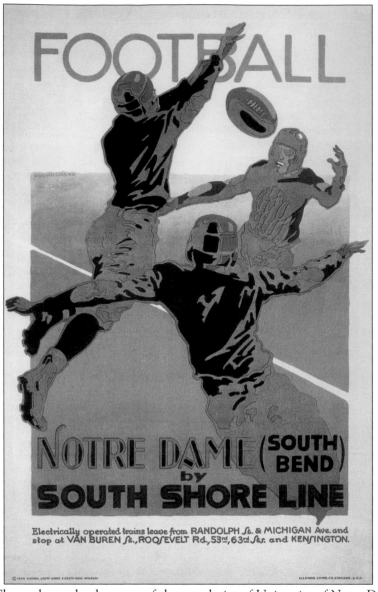

The South Shore also took advantage of the popularity of University of Notre Dame football games. Fans started using the train to travel to games in Chicago and in South Bend as early as 1919. Sometimes special trains were created for these trips. As the 1931 college football season opened, for instance, the SS offered to transport fans to Stagg Field, at the Sixty-third Street Station, to see the University of Chicago "Maroons" play Cornell. For Northwestern fans, reaching Dyche Stadium in Evanston was accomplished with a quick transfer to the Elevated two blocks west of the station on Randolph Street. When Notre Dame played Northwestern, Soldier Field was easily reached from the Twelfth Street Station. Buses waited for fans at the South Bend station to take them to Notre Dame Stadium. A complete schedule of the Notre Dame games was published in *South Shore Lines*, and South Shore patrons could purchase Notre Dame home-game tickets at the Randolph Street, Sixty-third Street, Hammond, East Chicago, Gary, and Michigan City stations up to 10 days before the game. This poster was another Otto Brennemann 1926 lithograph. (Author's collection.)

Five
DECADES OF DRAMA

The years after World War II brought prosperity to the South Shore, but they also brought the Interstate Highway System, which cut into its passenger and freight revenues. It was also the era of railroad mergers and the elimination of redundant routes. Stiff competition required constant cash outlays to maintain infrastructure and rolling stock. What's more, the usefulness and feasibility of passenger service was constantly called into question. By the end of the South Shore's first century, it went through three more owners. Under the fourth, it was separated from the freight division to be operated by a nonprofit entity only looking to balance expenses with ticket revenues and government subsidies. At this point, although it was still called the South Shore locally, it had become the Northern Indiana Commuter Transportation District, similar to METRA in Illinois, which by then owned the Illinois Central's suburban service.

At the end of World War II, CSS&SB was a player in the Calumet region freight business. When a Russian order for electric locomotives was canceled by the state department, the CSS&SB snapped up three of them. Retrofitted at the Michigan City shops, they helped to capitalize on business generated by the new mills along the lakeshore. They were nicknamed "Little Joes" in reference to Joseph Stalin, the head of the Soviet Union. (Courtesy of Hammond Public Library.)

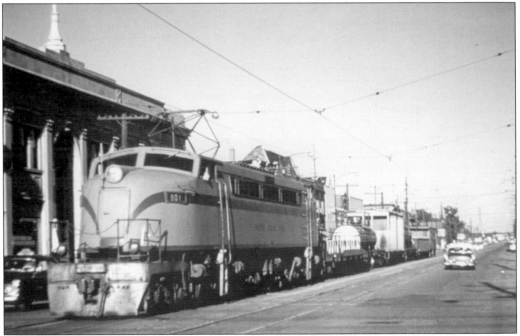

The last run for the Little Joes was in 1981, but until then they rolled down the middle of LaSalle Street in South Bend and Eleventh Street in Michigan City. No. 801 is seen here westbound on Chicago Avenue in East Chicago. By 1950, more than 100,000 carloads of freight were handled annually. It eventually became intolerable to have such behemoths rumbling through residential neighborhoods. (Courtesy of CRA.)

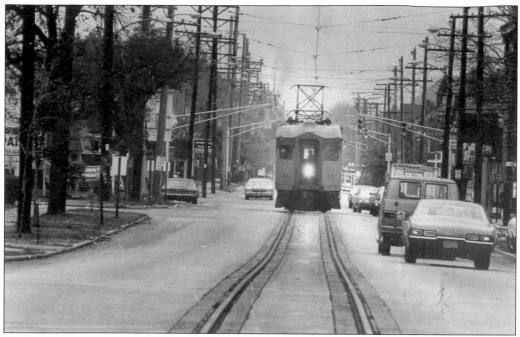

Traffic congestion increased after World War II, with trains still running down the middle of busy thoroughfares in Michigan City (above) and South Bend (below). The mayors of East Chicago and South Bend were very public and vociferous about this problem as early as the 1930s. The mayor of East Chicago once threatened to barricade Chicago Avenue to prevent the SS from using the same double-track route it had used since 1908. In all the towns, passenger and freight trains had to obey traffic signals and give way to other rail lines that crossed their tracks just like automobiles. In 1940, the mayor of South Bend declared he was doing battle with the SS to get them out of the downtown area. The freight trains were the worst. Early interurban franchises did not allow daytime freight hauling, but World War I demands had changed that. In 1920, residents along LaSalle Avenue petitioned the city council for an ordinance prohibiting the movement of dirt excavated for the LaSalle Hotel through their neighborhood. (Courtesy of CRA.)

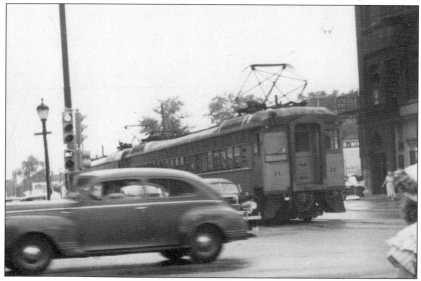

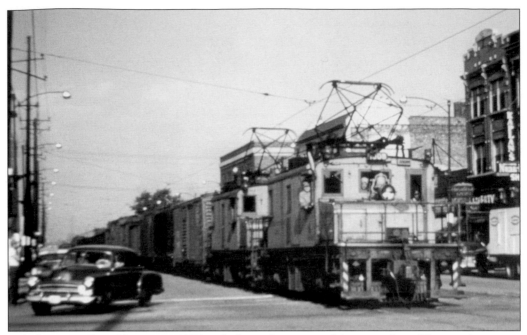

Relief came to East Chicago in 1956 with the realignment of the route from Chicago Avenue to vacant land south of town. Tracks were moved to an elevated line that was five miles long and paralleled the new Indiana Toll Road. This route crossed 15 trunk and belt lines without having to give way. It is still the most dramatic change to the route in the railroad's history. (Courtesy of CRA.)

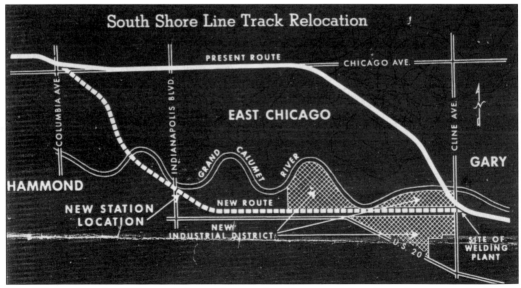

The SS developed a 270-acre industrial tract along its new right-of-way, known as the South Shore Industrial District, and several companies were already building facilities there. The new right-of-way was double tracked, and with embankments and bridges, it had avoided 27 railroad crossings and 28 street or highway crossings. The high point of the elevated section is at Columbia Avenue, 33 feet above grade. (Courtesy of *Modern Railroads*.)

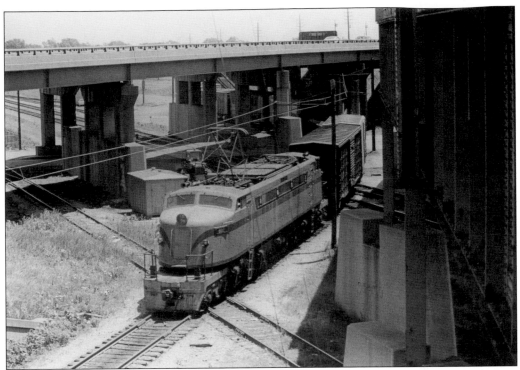

A "Little Joe" running beneath the Indiana Toll Road illustrates how the South Shore and the toll road commission worked together to develop the optimum route. Money was saved by using the same contractors on parallel bridges and gradings that were built at roughly the same time. Working with the toll road also gave the railroad the most favorable curvature through already developed neighborhoods in Hammond and Gary. (Courtesy of CRA.)

Meanwhile, the passenger cars, remnants of the jazz age, were physically falling apart and not up to the latest standards for passenger comfort. This interior is from car 203. The armchairs were from a bar car, an idea that was put into action in the 1970s but did not solve the difficulties of declining revenues and increasing expenses for the passenger division. (Courtesy of IDNL.)

In the 1960s, as the CSS&SB continued to evolve, the Chesapeake and Ohio Railroad System assumed control of the line and took hold of 94 percent of its stock. With that, a small interurban became a heavy electric railroad, fully integrated not only with other lines and industries in the Calumet region but also with the entire North American railway network. (Courtesy of LCHS.)

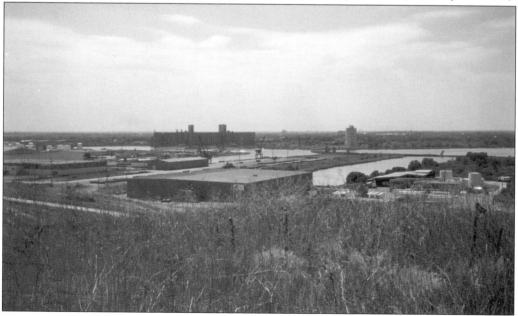

Among the C&O's business objectives was gaining trackage rights into the Chicago Regional Port District at Lake Calumet Harbor (seen here). Elsewhere, it was negotiating for business with new factories at Gary, New Carlisle, and Michigan City. One of its biggest customers was NIPSCO's Bailly Generating Station, which opened in late 1962. (Author's collection.)

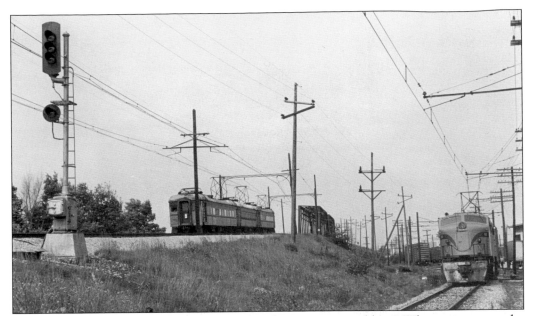

The C&O's biggest roadblock, however, was "the passenger problem." Whatever success the company had with its freight business was offset by passenger revenues that could not keep up with passenger service expenses. Several times in the 1960s and 1970s, the C&O petitioned the Interstate Commerce Commission (ICC) to abandon the passenger business entirely. (Courtesy of CRA.)

Although the ICC never allowed outright abandonment, South Shore employees and passengers felt threatened. In an attempt to catch the attention of members of the Indiana General Assembly, South Shore employees put the decal seen here on trains in a reference to a children's book of the same name. The situation did not improve. (Courtesy of IDNL.)

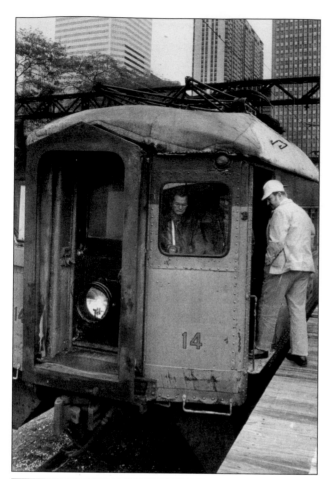

While the C&O sank as little money as possible into maintaining cars that had seen almost a million miles of service, the people who had to ride in them called them "Orange Crates," "Yellow Perils," "the V.C.," or the "Vomit Comet." The stations, too, had all seen better days. (Courtesy of CRA.)

South Shore passengers voiced their position about the matter by organizing Save Our South Shore (SOSS) in Michigan City and South Shore Recreation in Chicago. The latter focused on the recreational destinations made possible by the South Shore line and led many excursions to prove its point publicly. The former emphasized the economic efficiencies of public transportation in the 1970s and again in 1987. (Author's collection.)

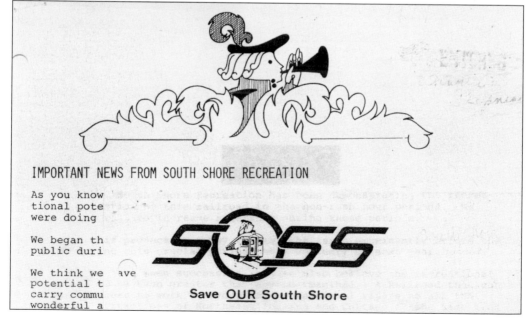

IMPORTANT NEWS FROM SOUTH SHORE RECREATION

As you know
tional pote
were doing

We began th
public duri

We think we ave
potential t
carry commu
wonderful a

Save OUR South Shore

State and local governments in Indiana finally organized the Northwest Indiana Commuter Transportation District (NICTD) in 1977. By enabling it to accept federal funding and match it with in-state monies, passenger service was saved. (Courtesy of LCHS.)

Within three years, NICTD was able to place an order with the Sumitomo Corporation of America for 36 stainless-steel passenger coaches. The prototype car arrived in Michigan City for testing (seen here) in January 1982. The cars' bodies and the trucks were manufactured in Japan, while the traction motors, control systems, brakes, air-conditioning, and seating was made in the United States. The cars were assembled in Cleveland. (Courtesy of CRA.)

Another five cars arrived in August 1982, and the full fleet began operating in November, as seen here near Lydick, Indiana. Seating 93, with air-conditioning and other amenities, they were comparable to mainline commuter trains. The last of Insull's jazz-era cars were retired in September 1983, having racked up more than one million miles each. (Courtesy of Hammond Public Library.)

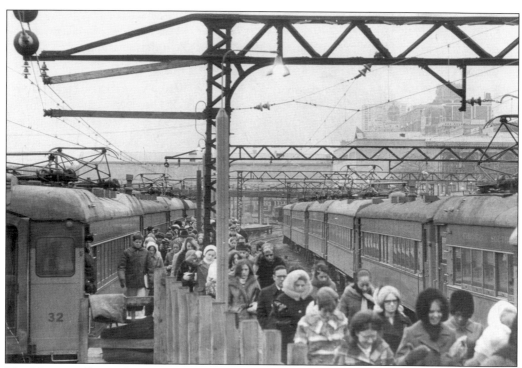

The Venango River Corporation bought the CSS&SB in 1984. Then, after several years of turmoil, it filed for bankruptcy in 1989. The NICTD seized the opportunity by reaching an agreement with Anacostia & Pacific that allowed it to buy the passenger service and equipment in January 1990. The freight division then became SouthShore Freight, allowing the NICTD to concentrate on infrastructure renovation and passenger convenience. (Courtesy of Calumet Regional Archives.)

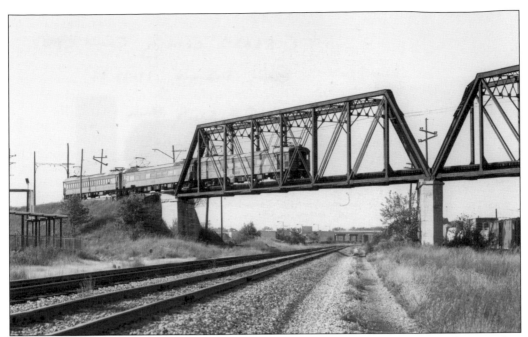

By the late 20th century, line infrastructure and bridges were due for repairs as well. Erected in 1906, the Pennsy-Wabash Bridge (seen here) was also called the "gauntlet bridge" and crossed the Pennsylvania and Wabash rail lines near Third Avenue in Gary. A Pratt through truss bridge fabricated at American Bridge Co. in Gary, it was held together with rivets. (Courtesy of CRA.)

The new Penn-Wabash Bridge was dedicated in 1995 by NICTD. It was designed by Cole Associates, Inc., of South Bend and constructed by Mellon Stuart Heavy & Highway, Inc., of Chicago. The old bridge was hauled away in the spring of 2002 to a private storage facility in Michigan City. (Author's collection.)

Between 1990 and 2005, stations along the line were also renovated. The last completed renovation was the Randolph Street Station, which is now called Millenium. Construction machinery and methods had changed since the 1930s renovation—but the delays had not. The station and platforms were under construction for nine years, beginning with the emergency closing of the retail spaces in 1996 and the installation of Millenium Park above it. (Courtesy of Robert E. Pence.)

Millenium Station (pictured) opened in 2005. Still underground, it is cleaner and brighter than the previous one, with gray, blue, and chrome as its color scheme. Curved metal lines inlaid in the floor help direct passengers over the sloping floor to the South Shore's ticket counter. The South Shore, or NICTD, also gained employee and maintenance space reached from the outdoor, sheltered platform area. (Courtesy of Robert E. Pence.)

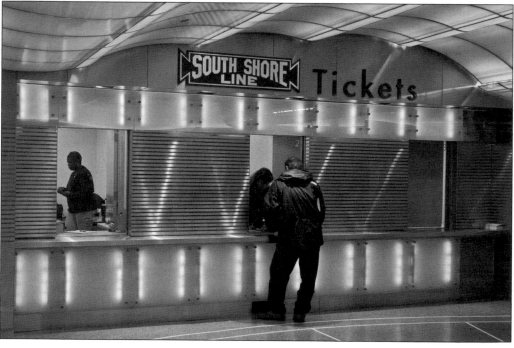

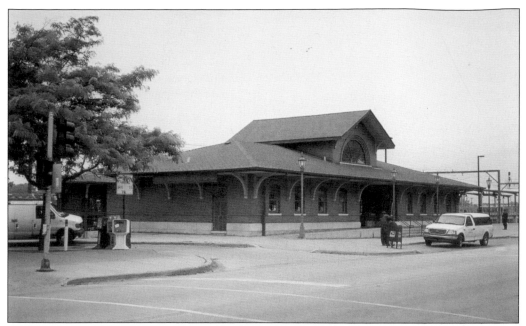

A new station at Hegewisch was completed in 1992 about three blocks southeast of the former site. Automobile parking was expanded next to the station as well as on the other side of Brainard Avenue. The spacious masonry building has a Craftsman-style feel to it inside and out and is the only station on the line to keep its owner-operated snack bar. (Author's collection.)

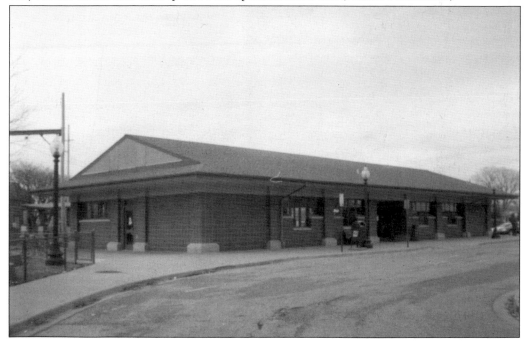

The old stucco station in Hammond was replaced in 1996. A snack bar and restrooms were provided, and one of the wooden benches in the new station was salvaged from the old one, as were some of the platform pavers that were used in the station's landscaping. As funds permitted, each of the stations was fitted with raised platforms. (Courtesy of Hammond Public Library.)

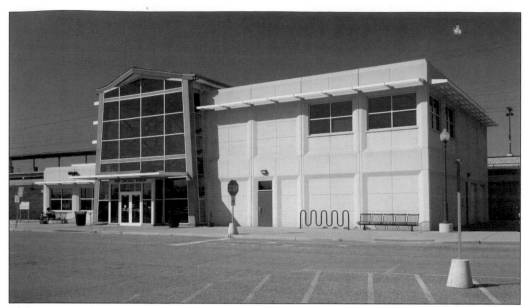

The passenger station at East Chicago opened in 1956 at the new right-of-way off Indianapolis Boulevard. Transfer bus service was increased in the hope that more suburban riders would be attracted. With the 2005 remodeling, the station has some retail space inside and includes the offices of the NICTD Police Department at track level, reached from the outside by a reversible escalator. (Courtesy of Robert E. Pence.)

When the latest Gary station was built in 1984, its designers incorporated an elevated, single-island platform some distance from the waiting room that could be reached by a skywalk. The station, to the right, shares the Adam Benjamin Metro Center with the Gary Public Transportation Corporation offices and terminal and Greyhound bus lines. (Courtesy of Robert E. Pence.)

The Dune Park Station, named for the section of the Indiana dunes destroyed in the 1960s to make way for the Port of Indiana and the Bethlehem Steel plant, was completed in 1985. It replaced the Tremont station and became home to NICTD's corporate offices. It is surrounded by the Indiana Dunes National Lakeshore and is still the stop for the Indiana Dunes State Park. (Courtesy of Robert E. Pence.)

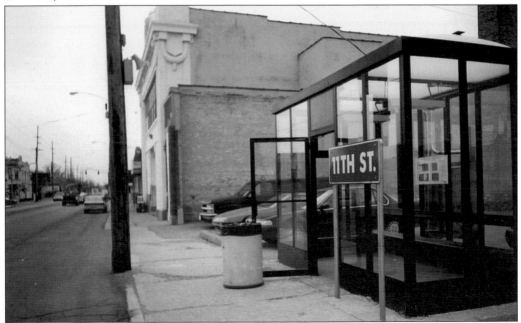

Although the building still stands in 2012, the station on Eleventh Street in downtown Michigan City was closed and replaced with an outdoor, glass and steel shelter. The bus terminal is long gone, as is the bus garage that once occupied the parking spaces on the east side of the building, which was razed in 1976. (Courtesy of LCHS.)

When the NICTD opened a 5,600-square-foot addition to its Carroll Avenue offices across from the shops in 1994, it placed a Plexiglas waiting booth for passengers out in the parking lot. Inside the office, there were a ticket agent and public restrooms with a small waiting area. This has become the main Michigan City station. (Courtesy of LCHS.)

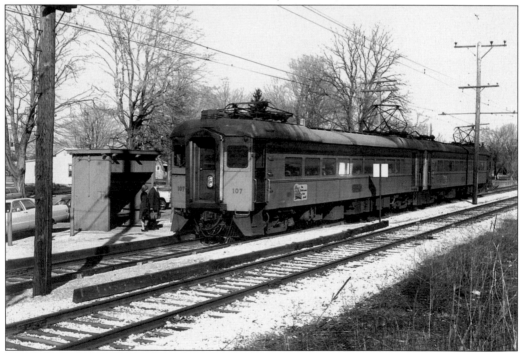

The sign of the South Shore at New Carlisle used to be a classic wooden flag stop hut painted orange. Service to New Carlisle from South Bend or Michigan City began in June 1908 and ended in 1994. Today, the closest stop is on Chicago Road at Hudson Lake. (Courtesy of Historic New Carlisle, Inc.)

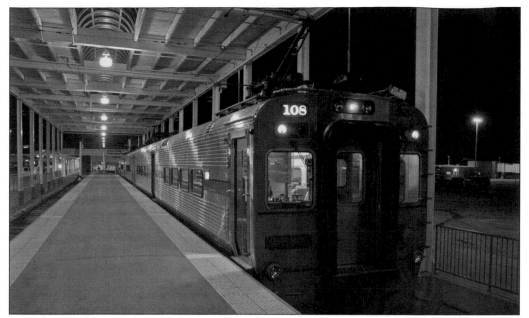

With NICTD ownership, money became available to move the South Bend station from its isolated site near Bendix on the west side of town to its fifth location at the Michiana Regional Airport, where there is ample parking and a comfortable waiting area inside the terminal. Service from the airport began in November 1992. (Courtesy of Robert E. Pence.)

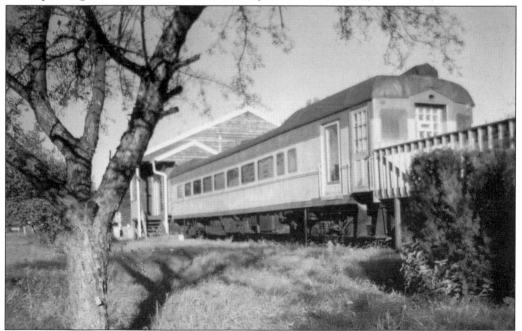

Once the new cars went online, NICTD began disposing of the old ones. A few were scrapped, but many of the cars went to private and public collectors. This one became part of a printing plant in Chesterton, Indiana. Car 33 moved on to Michigan City, where it was supposed to become a visitors' center. Five more were shipped to Bloomington, Indiana, for tourist trolley service. (Courtesy of Hammond Public Library.)

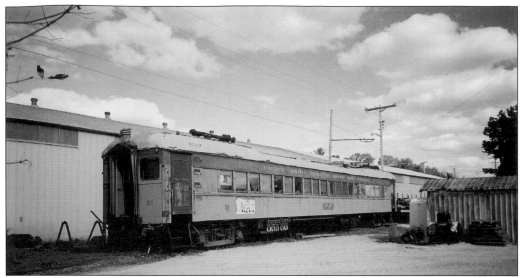

Car 21 (pictured) is now at the East Troy Railroad Museum in Mukwonago, Wisconsin, car 13 wound up at the New York Central Railroad Museum in Elkhart, Indiana, and car 7 can be seen at the Fox River Trolley Museum in South Elgin, Illinois. The Indiana Dunes National Lakeshore was also the recipient of several cars but has since donated them to other entities. (Courtesy of LCHS.)

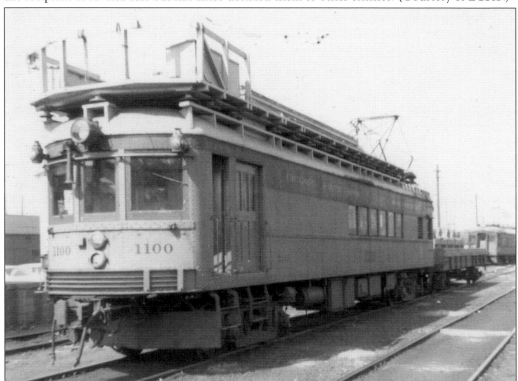

Line car 1100 probably has the most varied history of all the early cars. It was built as a combine in 1926 by the St. Louis Car Company for the Indiana Railroad, another interurban. The South Shore bought it in 1941 and converted it to a line car in 1947. After some 77 years of service, it was sold to a private buyer in 2003. (Courtesy of CRA.)

Six

THE PANORAMA
FROM THE WINDOWS

Although the sound of the South Shore's horn in the night is romantic, nothing beats the thrill of boarding and riding one of the trains to parts unknown. From downtown South Bend on the east to downtown Chicago on the west, through farms, open land, small towns, industrial sites, and big cities, there are more than 100 years of historic sights to see—and ghosts of sites to imagine. The evolution of the landscape through which the South Shore runs is just as interesting as the railroad's business history. The CSS&SB celebrated its 100th birthday in 2008, and as the rail line has changed, so has the countryside through which it passes. And there is no better way to see it than through a train window.

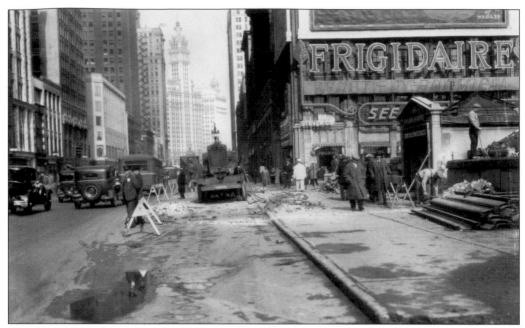

Northbound Michigan Avenue in downtown Chicago is seen here about 1930 as construction of the new Randolph Street Station was getting underway. The Wrigley Building is in the background. The building with the Frigidaire sign on it is now gone, and Randolph Street itself has since been extended across Michigan Avenue and eastward toward Lake Michigan, which is out of the photograph to the right. (Courtesy of ICRRHS.)

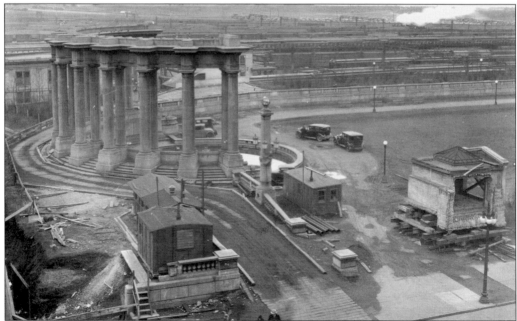

Seen around 1930 on the north end of Grant Park, to the left of the peristyle, is the construction site for the new Randolph Street Station and the viaduct that would carry the Randolph Street extension over the rail yards in the background to the new Lake Shore Drive. On the right, the former station entrance awaits its final disposition. (Courtesy of ICRRHS.)

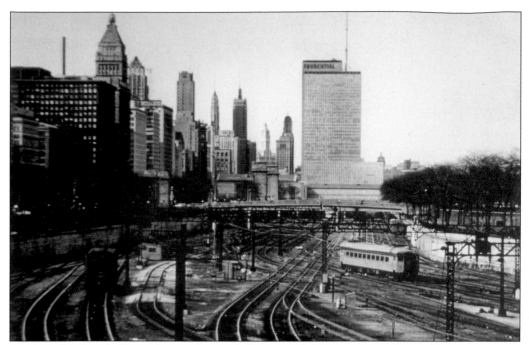

In 1932, the South Shore station (upper left) at Randolph Street was located between Grant Park and the IC rail yard. The IC suburban cars used the track on the left in the photograph. In the hazy background at the end of the yard are warehouses and other buildings on the Chicago River. (Courtesy of CRA.)

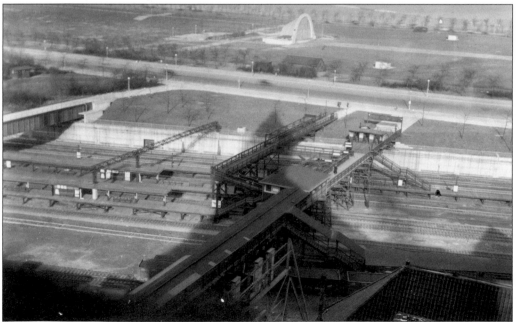

The Twelfth Street IC/SS station is partially covered by the shadow of the IC's Central Station tower. In the distance is the Band Shell in Grant Park that faces the entrance to the Field Museum. The Christopher Columbus Monument, sculpted by Carlo Brioschi, was also in this area; beyond is the new Lake Shore Drive bordered by Lake Michigan. (Courtesy of ICRRHS.)

The Standard Oil Building, now located on Randolph Street, was just north of the Twelfth Street Station on Michigan Avenue in the 1920s. The eight-story-tall signs on its south side advertise Red Crown gasoline. The lower floors are decorated with flag bunting, and a few of the offices above them have canvas awnings on the windows, as this was in the era of operable windows before air-conditioning. (Courtesy of ICRRHS.)

South of Twelfth Street is Soldier Field, built in the 1920s to honor Chicago's fallen soldiers. This aerial view from the 1960s shows the stadium packed for a sporting event with Northerly Island behind it. The island hosted the Century of Progress Fair in 1933 and 1934 and later was the site of Meigs Field airport. Lake Shore Drive parallels the IC right-of-way in the foreground. (Courtesy of The Aero Company.)

In the 1920s, the IC right-of-way south of Twenty-second Street was about to become Burnham Park, built on landfill one-eighth of a mile wide and five miles long. The first building on the right, at 350 East Cermak Road, was designed by Howard Van Doren Shaw for Lakeside Press. Later, it housed R.R. Donnelley & Sons. It was converted to offices for Internet and telecommunications firms in 2001. (Courtesy of ICRRHS.)

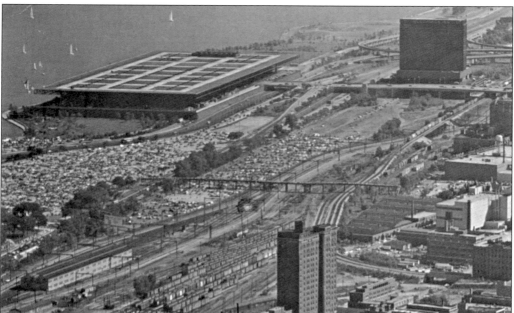

Some 50 years later, McCormick Place, the largest convention center in North America, was built at Burnham Park east of Lakeside Press and the IC right-of-way. The McCormick Inn is the tall building on the right. The railroad tracks are in the foreground with the catenary bridges for the electric commuter just visible in front of the light-colored maintenance building on the left. (Courtesy of The Aero Company.)

From the west windows of a southbound train, a traveler can spot the Stephen A. Douglas Monument at the foot of Thirty-fifth Street. Created by Leonard W. Volk in 1879, it is the oldest sculpted monument in Chicago. Volk, whose wife was Douglas's cousin, was well known for his portrait busts of Abraham Lincoln. A granite pillar supports a bronze statue of Douglas over his mausoleum. The four seated figures represent "Illinois," "Justice," "History," and "Eloquence." To the south of the monument is the Soldiers Home, built with funds raised by Chicago women hosting Sanitary Fairs during the Civil War. It opened in 1864 and cared for 700 wounded veterans before closing in 1870. Later, the Sisters of Carondolet established a home for handicapped children in the building. Both of these structures are located near the former site of Camp Douglas. The South Shore also passes Oak Woods Cemetery at Sixty-seventh Street, which is the resting place of 6,000 Confederate soldiers who died at Camp Douglas. (Courtesy of Photo and Art Postal Card Co.)

The University of Chicago was created in 1857 west of the Douglas Monument on land donated by Douglas. Douglas's estate, near the intersection of Thirty-first Street and Cottage Grove, was called Oakenwald. The only residential development remaining from that era is Groveland Park (seen here), a community of apartment buildings surrounding an oval-shaped private park. Douglas was also the first president of the university. (Author's collection.)

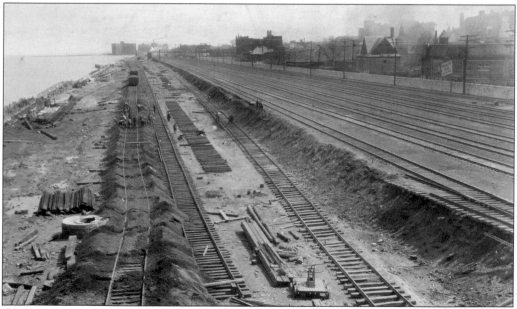

This photograph was one of many taken by the Illinois Central engineering staff in the 1920s to document the electrification of its commuter service; the view is from a footbridge over the tracks at Thirty-ninth Street looking south. Once the new track and electric lines were installed, the South Shore was able run its own cars into Randolph Street. (Courtesy of ICRRHS.)

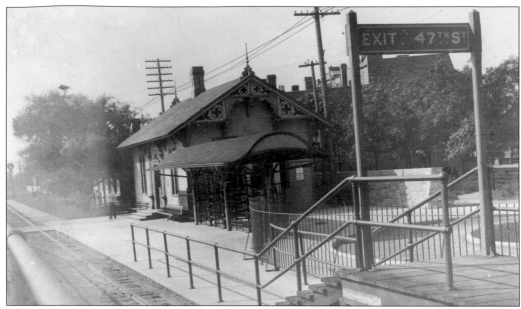

While the tracks were still on ground level, riders would have seen the Chalet-style Forty-seventh Street/Kenwood Station. Built around 1870, it housed a ticket office and a waiting room. The agent's living quarters were in a separate building beyond it. It was demolished in the 1930s. Kenwood, the neighborhood north of Hyde Park, is the home of current president Barack Obama and his family. (Courtesy of ICRRHS.)

Before 1889, Hyde Park was a separate village in the middle of Hyde Park Township. Many Chicagoans summered in Hyde Park, thus it had several apartment hotels, including the Hotel Windermere (seen here) and the Hyde Park Hotel. After her husband's assassination in 1865, Mary Lincoln and her sons Tad and Robert made their home at the Hyde Park Hotel for several months. Chicago annexed Hyde Park in 1889. (Author's collection.)

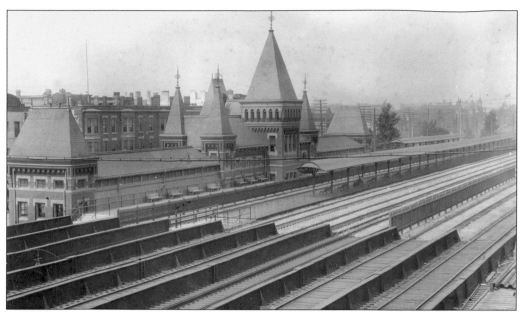

These two views of the Fifty-seventh Street/South Park IC station, street, and trackside illustrate how, in 1892, the elevation of the IC tracks changed the appearance of this High-Victorian Gothic edifice. In order to provide convenient and safe access to the World's Fair across the tracks in Jackson Park, pedestrian and vehicular subways were constructed, necessitating the raising of the track beds. The public was astounded by the number of passengers the IC picked up and delivered at this and other Hyde Park–area stations during the fair's 182-day run. The IC scheduled 40,116 "World's Fair Specials" from the Van Buren Street Station, delivering 8,780,616 passengers. The South Park station was relatively new at the time, having been completed in 1881. It had two waiting rooms, station agent quarters, a restaurant, and a baggage room. It was demolished in the 1930s. (Courtesy of ICRRHS.)

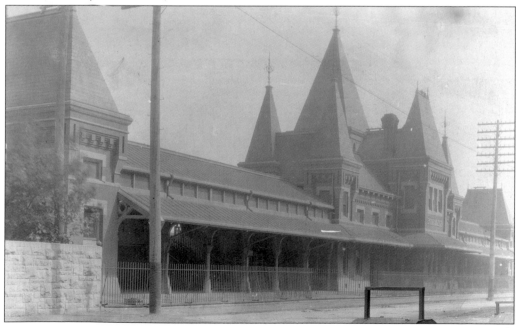

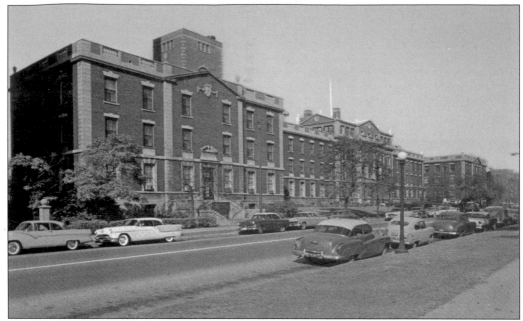

The Illinois Central, like many other big railroads, once provided its own hospitals and medical staff for their employees and families. This is the IC Hospital at 5800 South Stony Island (east side of the tracks) in Chicago in the 1960s. It also operated a hospital in Paducah, Kentucky. The Chicago hospital was later known as Doctors Hospital of Hyde Park until it closed in 2000. (Courtesy of Curt Teich.)

International House, 1414 East 59th Street, Chicago, dedicated 1932

On the Midway west of the Fifty-ninth Street IC station is International House at the University of Chicago. Built in 1932 by Holabird and Root, it was one of four such houses that John D. Rockefeller Jr. established to promote mutual understanding among students of various races and nationalities. It operated as a club for selected American and foreign students. (Author's collection.)

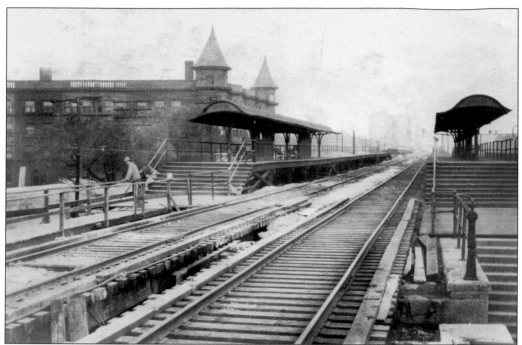

Above is the platform at Sixty-seventh Street, and below is the ticket office at the end of the platform. This was the station for the Oakwood Cemetery. Back then, as now, it was not a stop for the CSS&SB, but passengers would have seen it as they rode by. The construction is typical of the platform stations found between Sixty-third and 115th Streets, which were more important stops and rated substantial station buildings. This station was within the 1892 elevation project that eliminated all grade crossings between Forty-seventh and Seventieth Streets. By 1900, the IC was operating 31 trains each way at Pullman and Kensington, where it picked up CSS&SB passengers. (Courtesy of ICRRHS.)

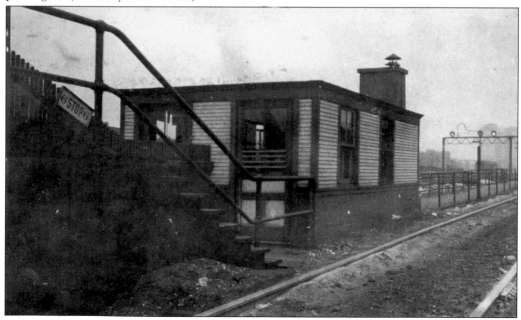

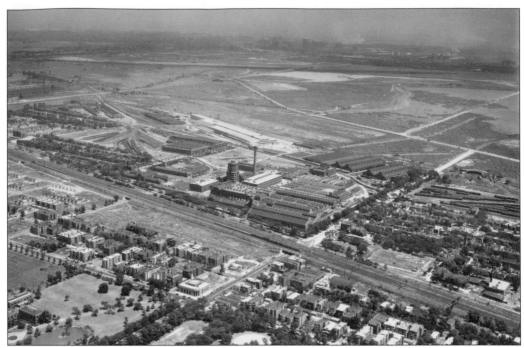

This aerial view shows the location of the Illinois Central Railroad in between the Pullman factory on the east and the neighborhood of Kensington on the west. Beyond the factory are Lake Calumet and the Chicago neighborhood of South Deering. To the right and out of this photograph, the South Shore parts ways with the IC as it turns east toward Indiana. (Courtesy of SCHS.)

The grande dame of Pullman, the Florence Hotel, seen here in the late 1950s, can be spotted from the train out of the east windows. It was named for George Pullman's daughter. Over its more than 100 years, it has hosted Pullman executives like Robert Todd Lincoln, restaurants, social meetings, and the Historic Pullman Foundation. Former Pullman Company executive housing and the Greenstone Church are nearby. (Courtesy of SCHS.)

The CSS&SB once crossed the Calumet River near 130th Street in Chicago on this swing bridge erected in 1908 by American Bridge Company. The bridge tender worked in the head house on top of the bridge, where he could see oncoming boats and barges and turn the bridge on its center pier to allow them to pass between the Cal-Sag Channel and Lake Calumet Harbor. (Courtesy of SCHS.)

The 130th Street swing bridge was replaced in 1966 with this fixed structure. A polygonal Warren through truss design, it was moved onto its piers with barges. Its eight panels are connected with rivets, and it is similar to many of the other railroad bridges spanning the Cal-Sag Channel. The boats approaching it have just left the O'Brien Lock. (Author's collection.)

This is a great view from the cab of a CSS&SB "Little Joe" locomotive as it crosses the new Calumet River Bridge in Chicago. On the left is the entrance to Calumet Harbor, and to the right is Hegewisch Marsh on the east bank of the O'Brien Lock and Dam. (Courtesy of LCHS.)

This aerial photograph shows the O'Brien Lock and Dam under construction in the late 1950s. In the middle of the lock, the St. Lawrence Seaway ends and the Illinois Waterway begins. The lock was opened in 1960. At this point, boaters change from Great Lakes rules of navigation to inland rules. The 130th Street South Shore Bridge is at the top of the photograph, below the highway bridge. (Courtesy of SCHS.)

The completed lock and dam are shown here with Hegewisch Marsh in the foreground. The water was once three blocks east, or towards the lower left, from where it is seen today. In 1938, the Calumet River was rechanneled to assist traffic on the Illinois Waterway, which connects the Calumet region to the Mississippi River. (Courtesy of SCHS.)

Hegewisch Marsh can be seen from the south windows of the train east of the lock. The land was once owned by Stephen A. Douglas, and in the early 1900s, the Chicago & Calumet River Railroad cut through its northeast corner. Federal and private funds have been presented to Chicago and the State of Illinois for restoration and development of a visitors and education center. (Author's collection.)

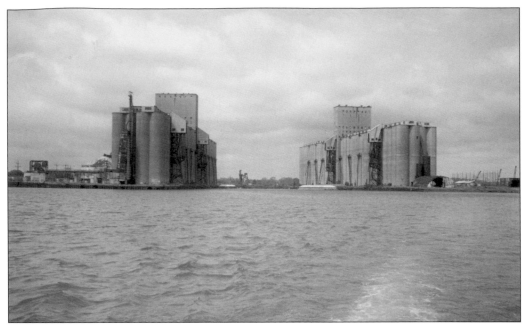

In the Calumet River valley, from the north windows of the train, riders can see the turning basin where the Calumet River meets the channel from Lake Calumet harbor. Farther into the lake are the grain elevators and slips for vessels of the St. Lawrence Seaway and the Great Lakes to load and unload. (Author's collection.)

East of the harbor entrance is the Ford assembly plant, a South Shore flag stop for workers between 1927 and 1955. The Ford City stop should not be confused with a shopping mall on Chicago's south side of the same name. The plant was built northwest of Hegewisch in 1923, and during World War II, it produced military vehicles instead of automobiles. (Courtesy of Calumet City Historical Society.)

After traversing the residential and rail yard scenery from the Calumet River through Hammond, the CSS&SB reaches Indianapolis Boulevard in East Chicago. Look quickly out the south windows to see the 1,781-foot-long "Nine-Span" Bridge. A riveted, Parker through truss, it was built in 1937 over railroad tracks on the east side of Hammond. (Courtesy of Indiana Department of Natural Resources/Division of Historic Preservation and Archaeology.)

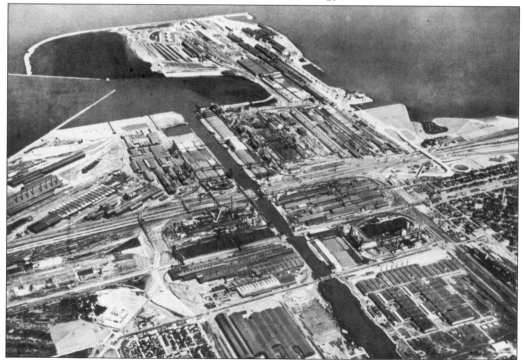

Before the CSS&SB right-of-way was moved out of downtown East Chicago, it crossed the Indiana Harbor Ship Canal (ISHC) on Chicago Avenue. The IHSC was the brainchild of Gen. Joseph Thatcher Torrence and opened in 1903. In 1927, the port was reported to have done more business than most of the ocean and lake ports in the entire country, including Calumet Harbor. (Courtesy of East Chicago Public Library.)

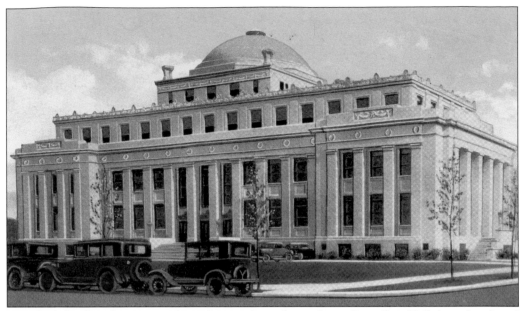

Two Gary landmarks are seen from the train's south windows. Gary City Hall (seen here) and the Lake County Superior Courthouse (opposite page) flank Broadway at Fourth Avenue. Both buildings are 180 feet by 80 feet and 43 feet tall. Each has a 26-foot-high dome on an octagonal base. The city hall, built in 1928 on the east side of Broadway, is pure Greek style in its ornamentation. (Courtesy of Gary Public Library.)

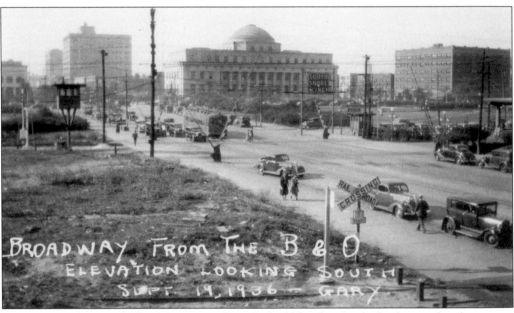

In 1936, Broadway and Third Avenue in Gary looked like this. In the background is the county court building, with the esplanade in front. The pillars of the South Shore station can just be seen on the right, and its neon sign is above the track gate. The oncoming trolley was part of the Gary public transit system, which served the mills north of the railroad stations. (Courtesy of CRA.)

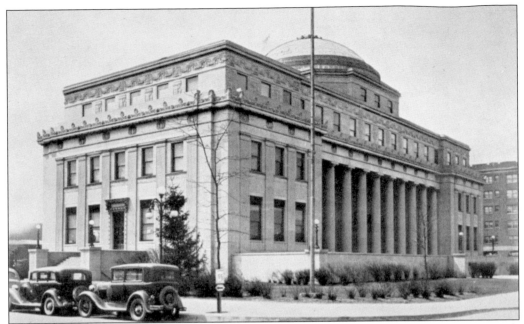

The Lake County Superior Courthouse was built in 1929 on the west side of Broadway at Fourth Street. Its exterior embellishments are of various styles. The esplanade across the street was landscaped with fountains, reflection pools, and terraces. This 10-acre "front yard" was begun in 1924 to separate the business center from the railroad lines and steel mills and to create a welcoming gateway to the city. (Courtesy of Gary Public Library.)

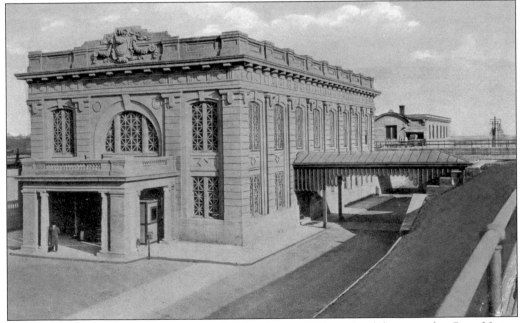

North of the esplanade was the railroad embankment and north of that was the Gary Union depot, seen here, which served the B&O and New York Central lines. It was connected by a tunnel with the freight house at the rear. Although the freight house is gone today, the neoclassical 1910 station can still be seen from the north windows of the train. (Courtesy of CRA.)

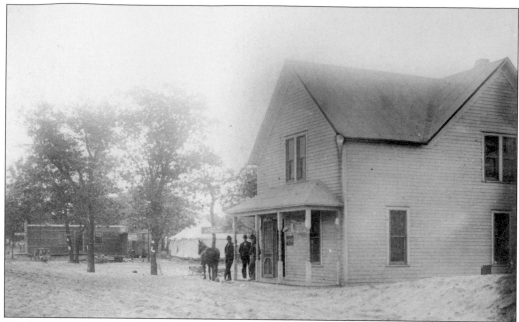

The building now known as the Gary Land Company, seen from the south windows of the train east of Broadway, was formerly on the site of the SS station. It housed the first post office, the city hall, and the office of the Gary Land Company. After its relocation to 537 Jefferson Street, it was a private home and the birthplace of opera star Kathryn Witwer. (Courtesy of CRA.)

Aetna, on the east side of Gary south of Route 12, is seen here during its 1950s building boom. It originated as a settlement around the Aetna Powder Company in the late 1880s. By 1906, company houses and dormitories had appeared. During the World War I years, the employee roster grew from 50 to 1,200, so by the 1920s, it rated a flag stop on the SLS&SB. (Courtesy of Gary Public Library.)

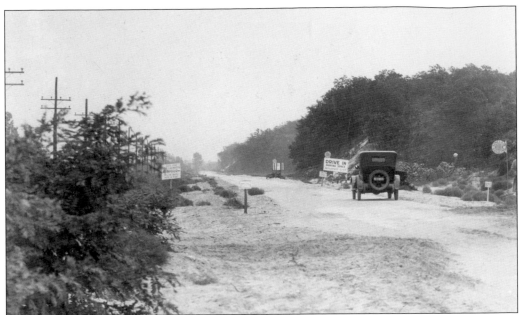

According to a 1927 Ogden Dunes Realty Company plat, this gas station on the right of the Dunes Highway was owned by the Lee Oil Company. To the left was Hillcrest Road, the entrance to Ogden Dunes and the location of the South Shore flag stop of Wyckliffe, about a mile from the beach. The electric service poles on the left indicate the location of the tracks. (Courtesy of CRA.)

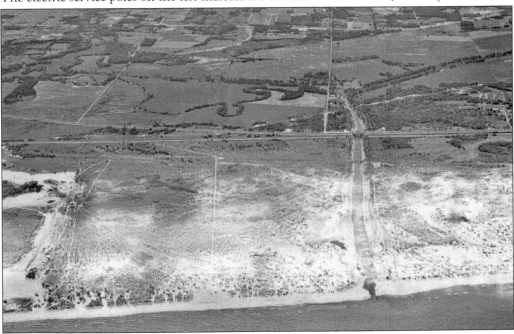

In the early 1920s, Burns Ditch was completed, rendering a significant portion of north Porter County farmable by draining its marshes through the dunes into Lake Michigan (bottom of the image). To the right of the waterway is Ogden Dunes. On the left, Midwest Steel and the Port of Indiana were built in the 1960s. The CSS&SB crossed the waterway on the upper bridge. (Courtesy of IDNL.)

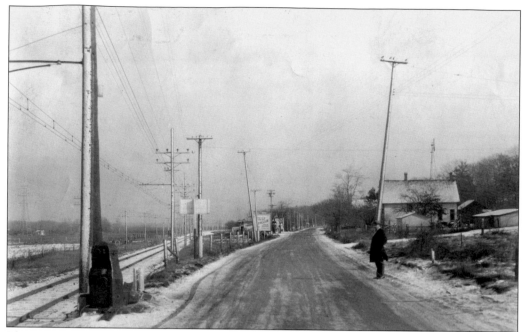

The South Shore (left) paralleled Route 12 in a roughly east-west direction here at Baillytown. To the right were the Little Calumet River, farmland, and the site of the 1822 Bailly homestead. On the left were the marshes and dunes that fronted Lake Michigan. The Chellburg family farmed in this area, shipping milk and produce to Chicago via the South Shore. (Courtesy of Gary Public Library.)

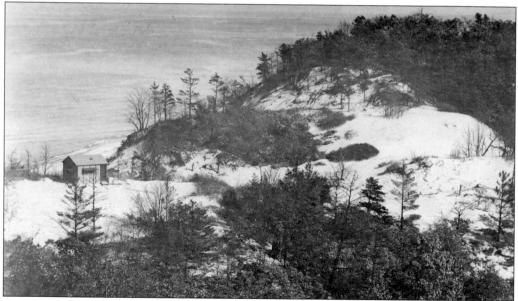

Artesian wells brought the health-conscious to the Knotts and Carlsbad Mineral Springs for the curative powers of mineral water. Carlsbad offered cabins and a restaurant. Armanis Knotts bottled his spring water for sale and also ran the Mineral Springs Jockey Club, a horse track, between 1911 and 1913. Mineral Springs Road was the South Shore flag stop for the spas and later for the town of Dune Acres. (Courtesy of Gary Public Library.)

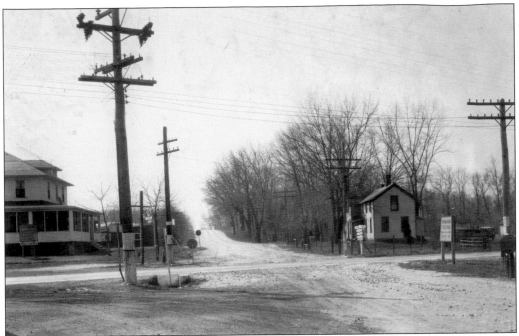

At Tremont, there was a two-story hotel (left) and bar on Route 12, across the tracks from the station. Also in the neighborhood were a motel, a lumberyard, a South Shore section house, a restaurant, and a real estate office. At one time, there were around 50 summerhouses north of the tracks. Directions to the state park were given on the sign on the right. (Courtesy of IDNL.)

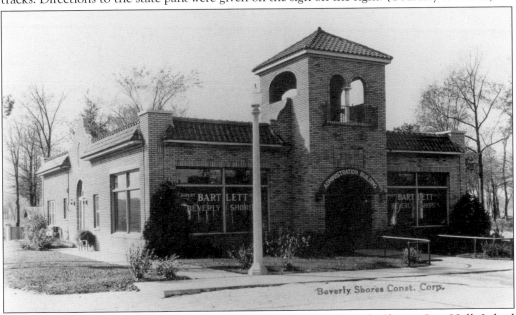

In 1946, this Mediterranean Revival–style building became Beverly Shores City Hall. It had been the Bartlett Real Estate office since 1927, when Fred Bartlett collaborated with Sam Insull to promote residential development in northwest Indiana. Bartlett was a well-known Chicago developer and had hoped to turn Beverly Shores into a posh resort area. In 2004, the building was added to the National Register of Historic Places. (Courtesy of IDNL.)

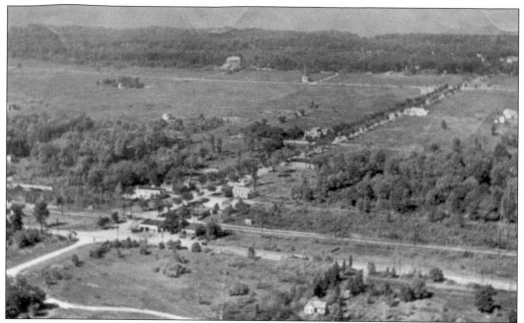

The crossroads of Broadway, the CSS&SB, and the Dunes Highway is in the lower left of this photograph of Beverly Shores. The original plans called for an inn, a riding academy, a theater, and a casino. Only the casino, on the lake at the end of Broadway, survived the Depression, as a restaurant called the Red Lantern that was later swept away by winter storms on Lake Michigan. (Courtesy of IDNL.)

The view from the north window of the train over the plain behind the dunes includes Mount Tom, Mount Holden, and Mount Jackson. The landscape has not change significantly since 1908 except that it is now part of the Indiana Dunes National Lakeshore and many of the buildings once seen from the train have been removed. (Courtesy of Gary Public Library.)

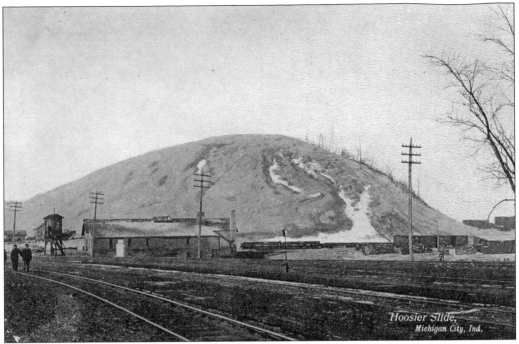

At 175 feet high, the dune known as Hoosier Slide was once a famous landmark on the west bank of Trail Creek at Michigan City. First, its trees were removed for fuel and building. The dune then became a tourist attraction and a spot for weddings. Finally, between 1890 and 1920, its 13.5 million tons of sand were hauled away to landfills and glass factories. (Courtesy of LCHS.)

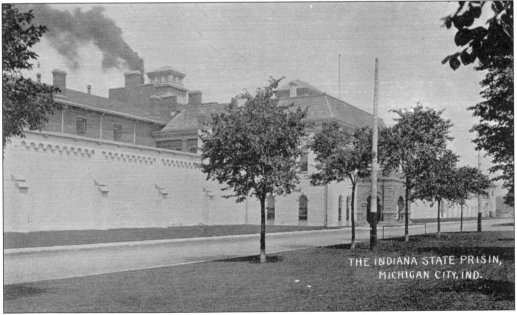

Indiana State Prison North opened on 100 acres of land west of Michigan City in 1860. It was the second such prison in the state, with the other located in Jeffersonville. In 1861, the prison school, taught by the chaplain, opened, and until 1904 prisoners worked for local manufacturers. The facility doubled in size around 1900. (Courtesy of LCHS.)

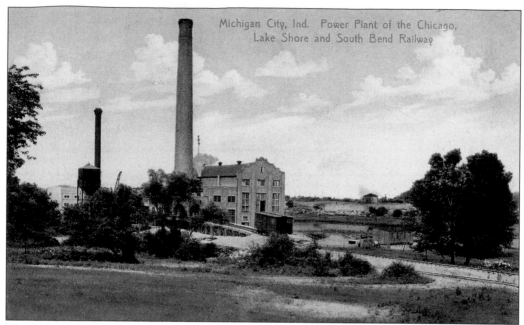

The CLS&SB built its generating plant on the site of the Hoosier Slide. The plant used 1500-kilowatt Westinghouse-Parsons turbo generators to provide the electricity for running the railroad, with some to spare for sale. The plant was upgraded in 1929 by Midland Utilities. (Courtesy of LCHS.)

Northern Indiana Public Service Company (NIPSCO), a Midland Utilities subsidiary, built all the new CSS&SB substations and feeder lines for the railroad in the late 1920s. A new generating plant with cooling tower (left) was constructed in the 1970s at the same site as the first plant on Trail Creek. (Courtesy of John Penrod.)

Riding through Michigan City, St. Mary's school and church can be seen from the north windows. A Catholic cemetery had been on the site before 1867, when two Michigan City parishes combined to build St. Mary's Church. The school and convent followed in 1886, serving mainly German and Irish parishioners. It is considered the "mother church" for all other Catholic parishes in Michigan City. (Courtesy of LCHS.)

At the Lake Park stop on the south side of Hudson Lake (seen here) there was a hotel and dance pavilion. The dance hall was razed during the Depression, and the hotel became a private residence. Other resorts at Hudson Lake were Britton's, on the north side, and Blue-Bird Beach, on Lake Shore Drive. Hudson Lake Beach Clubhouse, at Hickory and Poppy Lanes, belonged to seasonal residents. (Courtesy of Historical New Carlisle, Inc.)

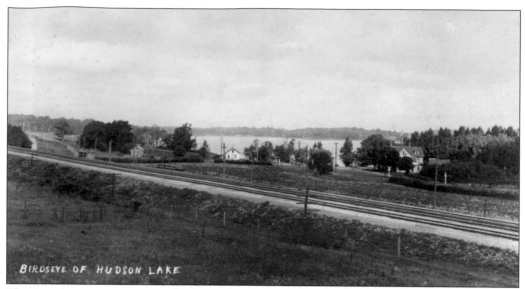

BIRDSEYE OF HUDSON LAKE

The Potawatomi name for Hudson Lake was Dishmau. French Canadian trappers called it Lac du Chemin, or "lake by the road," because the Chicago-Detroit Road ran along the east side of it. Lakeport became the first permanent settlement in 1835 and was a stagecoach stop on the Chicago Road. The western reach of the Terre Coupee prairie lies in and around Hudson Lake. (Courtesy of Historic New Carlisle, Inc.)

Lydick is the first stop in St. Joseph County. Once called Sweet Home, Indiana, it prospered due to the presence of the LS&MS, CSS&SB, and CSB&NI Railroads. The South Shore crossing at Quince Road, seen here, was also convenient to the Chain O' Lakes resort area north of town. (Author's collection.)

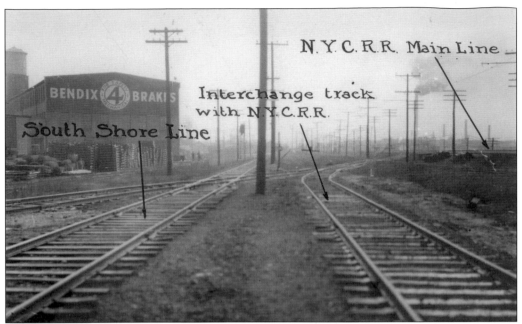

N.Y.C.R.R. Main Line

Interchange track
with N.Y.C.R.R.

South Shore Line

The Bendix area of the South Shore right-of-way has changed since the Insull days. The 1924 Bendix plant, which manufactured automobile brakes, is seen above. By 1928, Bendix was producing over 3.5 million brakes every year, selling most of them to General Motors. In 1929, it shifted to aviation products and changed its name to Bendix Aviation. Soon, there was Bendix Field, which attracted aviators from around the world. In 1970, the South Shore shifted its passenger tracks to the other side of the plant, seen below, and moved out of downtown South Bend to the west side, with a station at Washington Street that it shared with Amtrak. By the end of the 20th century, Bendix Field had become the Michiana Regional Airport. The South Shore moved its station there in 1992. (Above, courtesy of Northern Indiana Center for History; below, author's collection.)

The old route through South Bend ran on city streets, passing City Cemetery, which was established in 1832. Among the notables buried here are former Vice Pres. Schuyler Colfax and Pres. William McKinley's grandparents, who died six hours apart on their 42nd wedding anniversary. Two Revolutionary War soldiers, a number of Civil War veterans, and several members of the Studebaker family also rest here. (Courtesy of Northern Indiana Center for History.)

Before the South Shore left downtown South Bend, its station was on the corner of Michigan Street and LaSalle Avenue across the street from the LaSalle Hotel. The train yard was located at LaSalle and Hydraulic Avenues between the St. Joseph River (upper right) and the East Race. One track also crossed the East Race, ending near what is now Madison Center. The station building was demolished in 1974. (Courtesy of Curt Teich.)

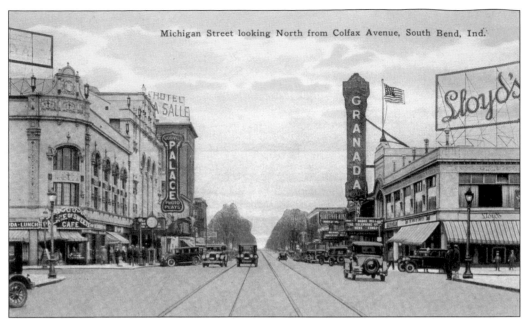

The Hotel LaSalle (back left) was across the street from the South Shore station in downtown South Bend. The nine-story, Classical Revival–style, brick and terra-cotta building was placed on the National Register of Historic Places in 1985. Proximity to theaters and restaurants as well as its own Parisian Tea Room made the LaSalle a popular place to stop. (Courtesy of Louis V. Bruggner.)

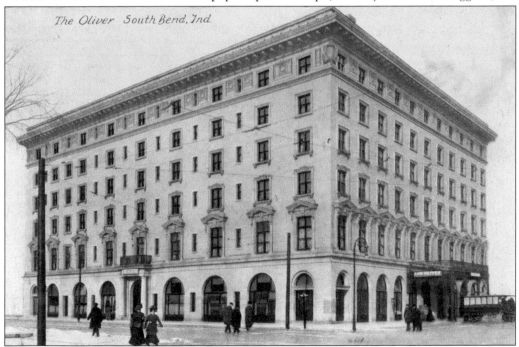

The Oliver South Bend, Ind.

The Oliver Hotel, on the corner of Main and Washington Streets, was within walking distance of the South Shore terminal. It was built by James Oliver of the Oliver Chilled Plow Company and opened in 1899 with 136 rooms. It was replaced by the Holiday Inn and City Center Building in the late 20th century. (Courtesy of Indiana Engraving Co.)

...I think I can

the little train that could

The South Shore, as writer Richard W. Conklin put it, is "[a]s much cultural artifact as transportation business." Since its inception, the rail line has had its ups and downs, but overall, it has served the Calumet region and the South Bend areas very well. It is hard to imagine the region without it. The railroad celebrated its 100th birthday in June 2008 with three days of events at the Michiana Regional Airport in South Bend and a new poster. Speakers included representatives of NICTD, Indiana University, and the Indiana Historical Society. They offered insights into the history, the present, and the future of the "little train that could." On the third day of the celebration, there was a round-trip train ride from South Bend to the shops at Michigan City. One hundred years after its mechanically challenged maiden run in the opposite direction, the South Shore showed that it was up for another hundred years of passenger and freight service. (Courtesy of IDNL.)

BIBLIOGRAPHY

Bach, Ira J. and Susan Wolfson. *A Guide to Chicago's Train Stations Past and Present*. Chicago: Ohio University Press/Swallow Press, 1986.

Carlson, Norman, ed. *One Hundred Years of Enduring Tradition: South Shore Line*. Lake Forest, IL: Shore Line Interurban Historical Society, 2008.

Chicago South Shore and South Bend Railroad. "First and Fastest." Commemorative booklet published by the railroad, 1929.

Cohen, Ronald D. and Stephen G. McShane, eds. *Moonlight in Duneland: The Illustrated Story of the Chicago South Shore and South Bend Railroad*. Bloomington, IN: Indiana University Press, 1998.

Conklin, Richard W. "Back on Track: The South Shore Enters a New Era." *Chicago Tribune*. October 16, 1983.

Corliss, Carlton J. *Mainline of Mid-America: The Story of the Illinois Central*. New York: Creative Age Press, 1950.

Groves, Dana. Images of America: *New Carlisle*. Charleston, SC: Arcadia Publishing, 2010.

Lloyd, Gordon E. *The Insull Chicago Interurbans: CA&E, CNS&M, CSS&SB in Color*. Edison, NJ: Morning Sun Books, Inc., 1996.

McDonald, Forrest. *Insull*. Chicago: The University of Chicago Press, 1962.

Middleton, William D. *South Shore: The Last Interurban*. San Marino, CA: Golden West Books, 1970. Revised, second edition. Bloomington, IN: Indiana University Press, 1999.

Myers, Edward T. "South Shore Builds Super Railroad," *Modern Railroads*. September 1956.

Parker, Francis H. *Indiana Railroad Depots: A Threatened Heritage*. Muncie, IN: Ball State University Department of Urban Planning, 1989.

Raia, William A. *Spirit of the South Shore*. River Forest, IL: Heimburger House Publishing Company, 1984.

DISCOVER THOUSANDS OF LOCAL HISTORY BOOKS FEATURING MILLIONS OF VINTAGE IMAGES

Arcadia Publishing, the leading local history publisher in the United States, is committed to making history accessible and meaningful through publishing books that celebrate and preserve the heritage of America's people and places.

Find more books like this at
www.arcadiapublishing.com

Search for your hometown history, your old stomping grounds, and even your favorite sports team.